ines

DAVID
HOCKNEY
AND HIS FRIENDS

Other Works by Peter Adam

Eisenstaedt by Eisenstaedt

Kertesz by Kertesz

Eileen Gray, Designer and Architect, A Biography

Art of The Third Reich

Not Drowning But Waving, An Autobiography

The Love of Men, Homoerotic Art from Antiquity to the Present Times

Absolute Press would like to thank David Hockney for his kind permission to use the paintings and illustrations reproduced in this book.

Outlines

DAVID
HOCKNEY
AND HIS FRIENDS

PETER ADAM

Absolute Press

First published in 1997 by Absolute Press
Scarborough House, 29 James Street West,
Bath, Somerset, England BA1 2BT
Tel: 01225 316013 Fax: 01225 445836
email sales@absolute press.demon.co.uk

Distributed in the United States of America and Canada by
Stewart, Tabori and Chang
115 West 18th Street, New York, NY 10011

Cover and text design by Ian Middleton

Covers printed by Devenish and Co. Bath
Printed by The Cromwell Press, Melksham

ISBN 1 899791 55 8

Contents

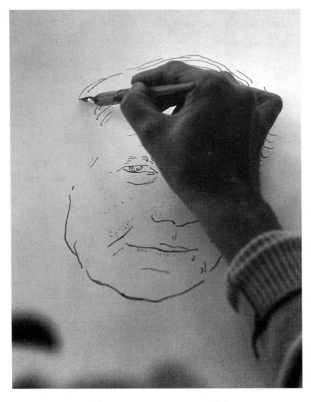

DAVID HOCKNEY
DRAWS PETER
ADAM
1980

'Friends, that's the only thread

running through my life.'

Introduction

In the spring of 1996 I travelled to Los Angeles, the latest in a series of visits to David Hockney. David and I have known each other for over thirty years. And although our lives have taken very different roads, we share enough common ground and many mutual friends for us to pick up the threads of our relationship when we meet again – surely the sign of a friendship of some consistency.

We had met in the early sixties through the painter Keith Vaughan, whom we both much admired and liked. Hockney displayed a mixture of modesty and self-assurance which was surprising for a man of his age, but, what struck me most at our first meeting was his engagingly earthy and original personality. Blessed with an inquisitive mind, he was so alive that ideas just came toppling out and he could talk for hours on almost any subject – Walt Whitman, Duccio, Gandhi, Durrell or Cavafy, amongst his favourites. His erudition was all the more compelling as it was mapped out not by a university but by his own curiosity and sense of spiritual exploration. He was, as the British art critic Bryan Robertson so wonderfully described, a mixture of 'shrewd artistic intelligence and Yorkshire opportunism'.[1]

There were periods when we saw quite a lot of one another, especially in his early years in London. I visited him several times in Los Angeles and we ran into each other in Paris, where he spent two years. Professionally we have also been involved with each other on several occasions. In 1980 I made a one-hour documentary film for the BBC, *David Hockney at Work*. I also persuaded him to take part in *One Hundred Great Paintings*, a series of one hundred short films in which several personalities took a look at their favourite paintings. Hockney was meant to have presented several of the

programmes, but by the time we started filming he was so busy that his contribution dwindled to the design of the opening logo, which is preserved on a rare T-shirt, and a programme about Vincent van Gogh's *Café Terrace in Arles* which I directed. Throughout all these years I watched his spiralling career and eventful life with interest and affection.

The voice in this book is his. This recollection is based on the many conversations we had, some conducted in front of the camera, many in private. In our latest one, in his home and garden, we talked without tape recorder or notebook, and without a precise objective. We talked about everything and nothing, about small and grave matters but most of all about friendship, about treason and wounds that do not heal, about the passing of time and the fragility of life. Sometimes the space was filled with long silences, sometimes silences turned into a soliloquy. Searching to recall an era that had disappeared long ago, Hockney spoke with a slightly ironic, tender tone, lapsing from time to time into a chuckle. As we were alone, he had dispensed with his hearing aid and so some of my questions drifted away in the clear Californian air, remained unheard or unanswered. He had always known how to delude if he did not feel the need to communicate. But gradually as we talked, his eyes sparkled and behind the barely wrinkled surface of his face, the old David re-emerged and I discovered that his earthy vitality was still all of a piece.

I have called this book, *Hockney and His Friends*, because friendships constitute the major axis of his life. 'Oh well friends . . . that's really the only thread running through my life, I mean the only one that has not been broken and tied together again.' Sipping strong cups of English tea, he conjures up the images of his friends who have been his 'family'. There are those he grew up with, others who were lovers or brotherly friends. Some simply drifted in, others were 'elected'. And some have become inseparable from his life, figuring prominently in his work: 'I like painting those who are around me; it is convenient and it is also enriching. I somehow seem to get to know them

much closer by painting them. I have hardly ever used a professional model, except in art school. That is a nice exercise, but it is not the same as drawing or painting a friend.'

I am aware that a book concentrating on Hockney's life will encourage an inclination to see him as social curiosity rather than as a committed artist, but his aesthetic concerns are so closely linked to his personal experiences that a look at the man might help to understand his artistic sense of purpose. He uses his work as a writer uses a diary. It is a concentrated autobiography, a lively and very personal response to what he loves, sees or reads, an intimate iconography. All his works are like monologues with himself, and he assumes that what interests him will interest others. His subjects are those of his daily life and grow out of his immediate environment. He has said, 'Painting is a way of seeing things that are just in front of my eyes.' His motivation to create comes from the way he feels. 'I paint what I like, when I like and where I like with occasional nostalgic journeys,' he wrote in a preface to an exhibition in the early sixties, and to a great extent this is still true today.

Charting his inner and outer development through his work can be as hazardous and surprising as his life. Few artists have conducted their lives as publicly as Hockney, and he has done so with the disarming innocence which has become the hallmark of his work.[2] But he is not a show-off or exhibitionist, and strong feelings are often disguised by wit, irreverence or down-to-earth humour. It was once said about him that it felt like having helped him on with his coat and, walking round to the front, discovering he wasn't there.[3] His work might be telling a lot, but there is little self-revelation. Mirrors and curtains appear in many of his paintings: 'they are always hiding and revealing something, that is their attraction for me.' Ultimately he is an elusive artist – just one of the many contradictions one accepts if one wants to understand the artist and love the man.

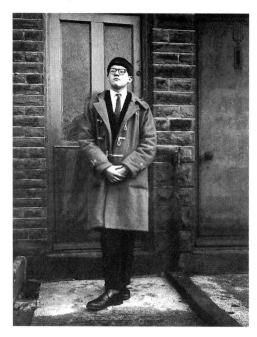

A YOUNG DAVID HOCKNEY
IN BRADFORD

'I like painting those who are around me; it is convenient
and it is also enriching. I somehow seem to get to know
them much closer by painting them. I have hardly ever
used a professional model, except in art school. That is a
nice exercise, but it is not the same as drawing or
painting a friend.'

The Bradford inheritance

David Hockney was born in 1937, the fourth of five children, in Bradford, a market town in Yorkshire. Much has been made of his 'working-class' background and although his father, Kenneth, was a clerk, Hockney's family was a far cry from the image of northern English working class. Hockney's 1955 portrait of his father shows an immaculately dressed man in white shirt, tie and waistcoat, sitting in a meditative mood, more the image of a university lecturer than that of a worker. Kenneth Hockney was extraordinarily well read on a wide range of subjects. He was a cultured man with liberal ideas, a sort of pacifist-atheist who supported various causes. He wrote long letters expounding his ideas of pacifism and vegetarianism to the likes of Nasser, Khruschev and Gandhi. Replies, if and when they came, were kept in brown paper scrapbooks, held together by string.

Kenneth Hockney was very particular about his looks. He was especially proud of his bow ties, but he also possessed several pairs of spectacles for different occasions – and several boxes of false teeth, labelled 'first rate', 'second best'. David's mother, Laura, was a private, deeply religious woman and a vegetarian. She saw to it that all her children adhered to her strict principles. Both her parents had been Methodists and Laura remained a teetotaller and a non-smoker all her life.

The family was certainly poor. David remembers his father's wages as being £4 per week. They lived in a small terrace house with a 'coal hole for a garden', whose faceless greyness David captured in his early sketchbooks. But, as he says, 'Poverty does not mean much to children as long as they have enough to eat, the fact that the house is not very big doesn't matter as long as

you're warm. The old might suffer and enjoy a little bit more, but the children don't care. Unhappy children are simply unloved children.'⁴ They were loved and he spent a peaceful youth, 'a genteel life in a genteel England', the fulcrum of so much of his later years. 'There were rows, but people were never put down.' As David explains, 'It was not all that unusual, the strong feeling for social justice and honesty was part of the Yorkshire culture and so was the desire for self-improvement.'

David went to the local grammar school, a time he remembers as marked by boredom. His school reports make funny reading. He showed 'ability' in Divinity, but did not concentrate. Most of his schoolbooks were covered with drawings and his English teacher noted that 'he still does not believe that an artist occasionally needs to use words'. In all other fields his lack of effort was criticized. Art alone was singled out as 'Good Work'. In order to escape the tedium of the curriculum, David did many drawings for the school magazine, including witty cartoons about school life, such as one of a boy with a broken leg holding up a sign; 'Complains About Compulsory Running'. The rebel and the iconoclast was already at work. Hockney won second prize in a competition for a newspaper advertisement for a pocket watch with his drawing of a young boy with a football scarf and the headline: 'Jimmy Always On Time'. The first prize was won by the sixteen-year-old Gerald Scarfe, later to become a famous cartoonist.

At about the age of eleven David had announced his ambition to become an artist, although he was not quite sure what it meant; 'I liked visual things, posters, postcards, things with a lot of colour, so I thought that's what an artist does.' Not that the announcement created much surprise, for his father had dabbled in art and had attended evening classes in his youth.

Both parents had a considerable influence on David, but especially his father who instilled in him ideas of social justice, and encouraged his inquisitive preoccupations. Kenneth had been one of ten children, and he was

determined to give his children the education he had never had. In addition to the endless stream of books borrowed from Bradford's Public Library, Kenneth took the children to the theatre, to the movies and once even to see *La Bohème* in the Bradford Alhambra. David also listened to classical music, mostly on an old tape recorder that Kenneth placed under his chair: 'There was very little visual education, but a lot of music. We used to go to hear the Hallé and the Yorkshire Symphony Orchestra, and whenever my dad took us, I sat in the hall, totally carried away by the waves of beautiful sound. This feeling of being lost in music is still with me, it is sort of central to my life.'

David also loved the cinema; it was his 'visual magic'. He went at least once a week to the dingy little movie house in the suburbs of Bradford, looking for a different and larger world. Delight in the moving picture and the theatre have remained with him all his life. His father's favourites were Laurel and Hardy, and the children never missed a showing. In those days, there was no television, but instead what was known as the 'steam radio', a big Console radio, above which their father had pinned a large map of the world so that they could identify the places mentioned in the news.

Having survived his early school years, David was desperate to go on to art school. A photo of him at the time shows him in a formal suit, sitting in the attic of his house in front of a large canvas. At the age of sixteen, his father gave in to his son's wishes and applied for him to be allowed to leave grammar school in order to study art. But the Education Office of the City of Bradford informed him that it was in David's 'best interest to continue his general education', 'for you will never make a living as an artist' was the often-heard argument. To this day the old resentment against this stifling system wells up every time David talks about it. But finally in 1953 he got a scholarship of £40 a year to go to the Bradford School of Art where he stayed until 1957, mostly painting and drawing what was around him, the local fish and chip shop, the semi-detached houses or a dog. He also took lithography as a subsidiary subject.

At that time, teaching in art school was still very traditional. The students spent two days per week on life painting and a further two on what was called 'figure composition'. One day was reserved for drawing. The work had to be realistic, displaying a proper knowledge of anatomy and perspective. This suited David. He was particularly interested in drawing from a life model. He often stayed on to attend the evening classes, meant for members of the public. This perseverance set the pattern for his life: 'I tend to think that you should work every day, and I do.'

Hockney's success began early: one of his first paintings, a portrait of his father, sold in a Leeds exhibition for ten pounds. Photographs from his student years show a diligent, serious and bespectacled young man with dark well-combed hair, in a suit and tie or a duffle coat, a very different image to the blond and eccentric bohemian the world recognizes today. The only indication of things to come is in a photograph of David at the age of sixteen: he strikes a Chaplin pose, wearing a dark suit, spats, a bowler hat and carrying a walking stick.

By the time he reached art school his appearance had begun to change, as several self-portraits reveal. In a 1954 painting, when David was seventeen, he looks like a boy of about thirteen who seems to scrutinize the world through a pair of large round glasses. This virginal look is in contrast to the formal clothes he is wearing; striped trousers, a black waistcoat, white shirt and tie. These two sides of himself, the pristine and the worldly, have never left him. The self-portrait is revealing in another way: David was not, unlike most of his sitters, handsome – or at least he did not perceive himself as such. Only in humorous pose or playing the clown did he accept his looks, which to his friends were utterly charming and desirable. He was attractive in an unconventional way, but he could not see it.

This awkwardness is also reflected in some of his later self-portraits. In *Love (Gandhi) (1960/61)*, the young painter looks like Gandhi, in another from the

same period he looks sad and old. In the years to come he painted himself again and again, as an odd-looking, owlishly bespectacled figure, often juxtaposed with beautiful boys. An etching in the series, *A Rake's Progress*, (1961) entitled *The Seven Stone Weakling* shows a young man with glasses looking at two athletic boys jogging.

In late fifties Bradford there was not much contemporary art to be seen and what the students studied was mostly English work by Walter Sickert, Victor Pasmore, Graham Sutherland, Roger Hilton, Terence Frost and William Coldstream. Some students were interested in the works of Keith Vaughan and John Minton, both homosexuals, whose drawings and paintings concentrated on the male nude. Hockney was also keen on Stanley Spencer, on whose eccentric lifestyle he tried to model himself. To see a wider international range of work he spent hours in the small library, leafing through books, looking for an art of which he dreamt.

After college Hockney was conscripted to military service, but as a conscientious objector, he served his two years working in several hospitals, drawing when he could. 'There was actually so little room for painting, I concentrated on drawing.' He got up at six every morning, which set the pace for the rest of his life.

David's excursions to London to look at 'big art, foreign art' were rare – he had seen exhibitions by Picasso, Francis Bacon, Magritte – but he knew that if he wanted to achieve his goal to become a painter he had to go to London to live.

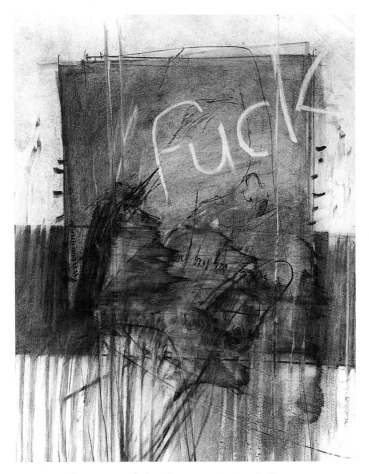

FUCK (MY BROTHER) 1961 CHARCOAL DRAWING

'As an artist you have to be honest

and accept your own sexuality.'

Coming out

In 1957, with the fierce determination that would carry him at breathtaking speed from obscurity to the brink of success, Hockney applied to two of London's most prestigious art schools, the Slade and the Royal College of Art. He wanted to study life painting, drawing and figure composition. Accepted by both schools, he chose the Royal College as it had the reputation of being more modern and forward-looking. He enrolled as a post-graduate in the Painting Department whose tutors included Carel Weight, Ceri Richards, Roger de Grey, Ruskin Spear and Sandra Blow. Unlike the Bradford College of Art, Hockney quickly discovered that the College imposed no strict rules. Students could paint what and how they chose and only life class was compulsory. All this suited him happily.

In his class were young men, all of whom, like Hockney, would soon make a name for themselves: R. B. Kitaj, Allen Jones, Peter Phillips, Derek Boshier and Patrick Caulfield. Another friend, Patrick Procktor, studied at the Slade. From the outset, it was clear that Hockney was different: his vision was shaped by a mutinous energy, a taste for adventures, intellectually and sexually, but also by a desire to communicate. He was one of 'the young meteors' of the sixties, whose rise took place almost over night.[5]

Hockney soon attached himself to Ron Kitaj. The choice was not surprising. Kitaj, four years older, was 'foreign', born in Ohio of European parents, and he had a lively interest in other cultures and in the past, qualities David valued. Few English students had been abroad whereas Kitaj's experience of the world was deep and broad. He had been a sailor and came from America, the dreamland of so many young people. He had lived in Vienna, and most

important, he also favoured figurative painting. To Hockney, 'Ron knew more about painting than anybody I had met.'

The other students did big abstract works, influenced by the American Abstract Expressionists, whose major show at the Tate Gallery in 1959 had had such an impact on London's artists. Hockney attempted some abstract paintings with impish titles such as *Bunch of Carrots* or *Two Cabbages* to reflect his vegetarianism. Other non-figurative images were entitled *Red* and *Shame*. In 1960 he did a small canvas called *Yellow Abstract* and in it, barely visible, he wrote the word 'Queer'. His affinity with non-figurative art has always been ambivalent although he admired some work and liked many of the artists. At first his relationship or the lack of it – with 'modern' art, worried him, but his heart simply wasn't in it. Later, he became more relaxed about it: 'It took me a long time to realize you can't make art outside of your period, so you shouldn't worry about this, it will always be of the period whatever you do.'[6] I remember visiting the Stedelijk Museum in Amsterdam with him, and David walking from room to room filled with abstract works, his face growing darker and darker. 'It's all so barren,' he finally said, rushing to the room with the van Goghs. 'Paintings should have content.'

In college, he was given a little cubicle to paint in and, as he lived in a very small room with just one electric fire, he spent a lot of time in his college cubicle, even receiving friends and dyeing his hair there – and once the principal caught him having a bath in the sink. He soon found his own home, a shed at the bottom of a garden in Earl's Court. David was fond of this rather run-down and sleazy part of London, full of bedsits and tacky hotels behind crumbling Victorian façades.

In order to come to terms with the problem of figure painting, Hockney drew all the time, mostly the nude male. He used to point out that painters who like to paint nudes always paint those they fancy. 'Renoir did plump women and Michelangelo muscular men.' He has always been interested in

the central role the human figure has played in the history of art, particularly
the figure of the male, and concerned with how men see their own bodies
and those of other men. During long periods in the history of Western Art
the presentation of the nude male has been shunned, particularly by the
Christian church. And, although Antiquity and the Renaissance condoned
the naked man, he had to be allegorized or represented as the ideal.

In the depiction of sex, most Western artists have used metaphor and allusion;
the overt presentation of sexual desire is rare. Art has always nourished the
anonymous pleasure of voyeurism, but the gaze has been mostly the
prerogative of men directed towards women. The presentation of naked
women – in their most intimate physical details, their bathing, their
abduction, their rape – has long been accepted as a legitimate subject for art,
but when men are shown in similar situations, many have considered such
representations obscene. The male nude had to represent heroism and
courage. The male body as a sexual object, or even presented in a more lively
pose, was seen as the ally of the devil and temptation. Hockney has always
rejected this notion of gay men having to catch their object of desire
furtively, in renderings of men bathing together or as a 'cleaned up' nude
striking an antique pose. Refusing the traditional representation of man as a
fighter, warrior, hunter, his images of the nude male are objects of erotic
desire and love – Hockney's erotic desire and love.

Hockney often complained about the plainness of the models in his college:
'Big sagging tits, they sit on chairs, their ass falling over on each side.' One
day he asked one of his friends, Mo McDermott, to pose for him in the life
class. Mo studied fabric design and as he was a great fan of Hockney's work,
he agreed. David and Mo became friends and Mo was for a time Hockney's
favourite model, later to become his assistant. Through Mo, David met two
other fabric designer students, also to become lifelong friends, Celia Britwell
and Raymond Clark, known as 'Ossie' as he came from a place called
Oswaldtwistle.

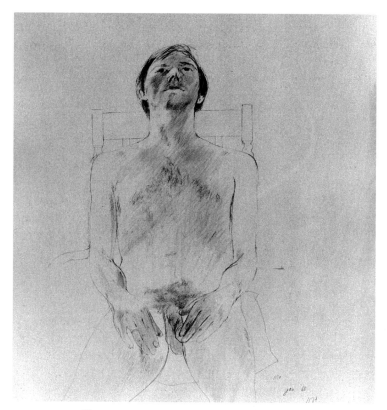

MO, NUDE 1968

But when Mo, who David thought 'cute and sexy', arrived at the College to model, the other students refused to draw or paint him. So David had him all for himself. Despite Hockney's gregariousness and desire for popularity, he was accustomed to being a bit of an outsider. His background and the underlying knowledge of his homosexuality set him aside from any prescribed alliances. It was not easy, as he has frequently pointed out, to 'connect'. The air of detachment and a refusal to conform has lasted all his life. Hockney

caught this Mo episode in a delightful work, *Painting for Myself*. It shows the naked Mo in a triple image, his discarded jeans and a striped T-shirt hanging on the wall. One day he discovered that another student had scribbled on the painting, 'Don't give up yet'. Far from being offended, this amused him and he left it on the canvas.

The London he found offered as free a life as he wished for and he began to acknowledge his homosexuality quite openly. 'As an artist you have to be honest and accept your own sexuality.' Like most homosexuals, he was aware of his sexual inclination from an early age: 'I knew it, I guess, when I was thirteen or fourteen years old.' Of course in Bradford this was never discussed, and David, out of a deep respect for his mother and father, would never bring it up, not even with his brothers and sisters. Later, his mother always thought that his hair was bleached by the sun and sometimes she insisted that David was 'born blond'.

So at first he was quite secretive and reticent about his homosexuality. He even 'dated a girl'. But then he realized that he had to face his 'difference'. 'When I was very young, you didn't think it was anything odd at all. It simply seemed quite private, and then the more aware you become, the more secretive you become. You've lost the innocence of not caring at all. Then the moment you decide you have to face what you're like, you get so excited, it's something off your back. I don't care what they think at all now. In a sense, oddly enough, it kind of normalizes you.'[7]

To this day Hockney intensely dislikes being labelled a 'homosexual artist'. As David looks out over the water, propping himself up on the edge of his pool whose bottom is painted in bright blue with a Hockney design, he shouts: ' I hate any label. I do not want to call myself thus, nor do I want anybody else to do it; I am an artist.' Not that he minds people knowing about it. He stretches out in the sun – he still has the lean figure of an adolescent although he is sixty – and, closing his eyes, he says: 'Of course you can spot the artist's

sexual inclination in his work. You can read it in a portrait, this love he feels for his sitters, but you can see that also in the portrait of my mother or my dogs. They would of course be different if these portraits were done by someone else, it would not have the same feeling.'

Hockney admits that 'many things would have withered if I were a heterosexual, and I always assumed in a way that I would be alone, you expect that as an artist, need it. No, I just accepted it. Most men have a deep desire to penetrate women, I do not share that. I am part of a minority. It's part of the texture of life. But I refuse to see it as an illness, it is something deep inside of you, as a human being.' Passion and anger well up easily in Hockney when he feels that society curtails his personal freedom. 'I loathe it when they say that homosexuality is a betrayal of the family, all that talk about "family values". My family are my friends, and I am deeply committed to them, but I also have a deep love for my own family.'

Much of his early work is concerned with sexuality. The love between men, with its possible and impossible dreams, was always a passionate theme. In later years he made room for other subjects, but it never lost its central role. Sexuality appeared for the first time in his work in the winter of 1959. This coincided with his 'coming out', although in his early student years in Bradford he had done a painting, *Erection*. In 1960 Hockney did a series of *Fuck* drawings. One, *Fuck (My Brothers)*, contains a self-portrait another, *Fuck (Cliff)*, from the same year, is full of personal messages in the style of lavatory messages.

Many of these drawings were student pranks, as was a fictitious review he wrote about the graffiti in the lavatories in the college. He wittily treated them like paintings exhibited in what he called 'La Trine Gallery in S.W. 7'.

Over the next few years the private messages became an open declaration of his love of men. 'Coming out' was quite an exciting moment for him, as it meant also becoming fully aware of his desires and longings. In an England

where a more permissive mood prevailed, the freewheeling atmosphere at the college produced many changes in David and the youth all around him. Many rebelled against their puritanical upbringing and began to experiment with all sort of things – drugs, sex, even homosexuality. David threw himself into London life with the enthusiasm of a child that knows no danger. These were the famous 'swinging sixties', a term mostly invented by the American media. David always hated the expression – 'snobbish, middle-class claptrap. Swinging Sixties meant miniskirts and all that, I would rather have had them showing less legs and keeping the pubs open a bit longer,' he remembers. But he enjoyed the energy and the fresh air that breezed through England.

One day David discovered that a new student at the college had quite openly plastered the walls of his cubicle with pictures from muscle magazines. He was an American called Mark Berger, handsome and sensuous and remarkably relaxed about being gay. The two became friends and Mark introduced David to some of London's gay nightlife. David remembers that at one party he met his first male prostitute by the name of 'Spanish Rick', 'a weird character in Lurex trousers and a cloak'. The other gay friend that helped him to come out was Patrick Procktor. He offered to take David to a drag ball at the Slade School and so David bought himself some eyelashes and rubber falsies and shaved his legs. He wore a T-shirt with 'Miss Bayswater' written on it. But something must have gone wrong as David was the only one in drag! Mark Berger always knew how to create fun, which attracted him greatly to David, who was still shy. Peter Webb in his *Portrait of David Hockney* tells of an evening in the college when Mark danced and sang American musical numbers in tails and top hat. He even persuaded David to join in after a few drinks. David went on stage and sang one of his father's favourite songs, 'Little Willie Woodbine, breaking into a Yorkshire clock'.[8] For the college's 1961 Christmas show David became bolder still. Sporting a blond wig and a silk skirt with a sequin top emphasizing his bust, he sang 'I'm Just a Girl Who Can't Say No'. Everybody loved him for it. Self-parody and camp irony were often used to confront a still mostly hostile public – not that the young David

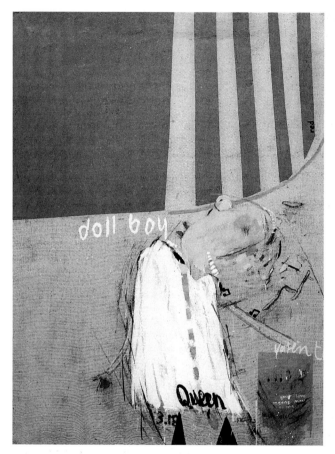

DOLL BOY, 1960-61, OIL ON CANVAS

He had a crush on the handsome teenage heart throb and pop idol of the sixties, Cliff Richard.

met such hostility from his fellow students. 'You couldn't shock students then, as you cannot shock students now' was his innocent verdict. He didn't talk much about homosexuality, it just came out in his paintings. The titles of some of his works from the sixties – *I'm in the Mood for Love, Queer, Doll Boy, Going to Be a Queen For The Night* – indicate the defiant stance he was taking. The interchangeability of the sexes was shown in a picture called *Bertha Alias Bernie*, the picture of a boy in a dress.

The defiance spilled over into his public image. Flamboyant in dress, exuberant in gesture, gregarious in his social encounters, David soon found great pleasure in being different. He began to wear colourful socks, sometimes a different sock on each foot. He had a crush on the handsome teenage heart throb and pop idol of the sixties, Cliff Richard. Richard was a sort of sanitized version of Elvis. He looked like a slightly chubby model for C&A clothes, but the clean-cut, boy-next-door image appealed to David and he thought Cliff was very sexy. He plastered the walls of his allotted space with photos of the singer. Of course this was also done to provoke, as other students had photos of pin-up girls on theirs.

Hockney's painting *Doll Boy* from 1960 is a homage to Cliff, a sort of Valentine card: 'valenti' is scribbled on the right side of the canvas. Valentine's day on the 14th of February is not only the day lovers exchange secret messages; it was also the name of a then-popular teenage magazine that frequently featured Cliff Richard. Hockney had made four preliminary studies for this painting, and with each his declaration of love became more audacious. The words 'doll boy' appears in all. In one he had also written the words 'unorthodox lover'. But only the final version gives us the complete clue as to whom this work was dedicated. The painting carries several coded messages. In the final oil the number '3,18' stands for 'C.R.' in the alphabet. There is also the line 'your love means more to me' and a heart with the letter 'D' pushes down the head of a young boy and hits at the oppressive force of male love. The rather ironic title referred to Richard's hit song,

'Living Doll' with its lines: 'Got myself a crying, talking, sleeping, walking living doll', which David had changed to 'Boy'. This was a reflection of Richard's constant effort to deny any hints of homosexuality and his claims that he 'preferred tennis to sex'. The boy in Hockney's painting wears a kind of baby-doll dress with the word 'queen' written at the height of his sex.

Pop art, like pop music, used sex as image and subject. The often rude, sometimes banal messages were part of the subversiveness of an art that challenged the given aesthetic and moral codes of the time. Hockney's paintings with their inscriptions, many from the lavatory at his local tube station in Earl's Court, were like propaganda leaflets in praise of the love of boys. They sometimes defiantly employed contemporary *argot* words like 'Queer'. *Going to be a Queen for Tonight* has 'queer' written several times over it, like some insulting graffiti that could still be seen on the walls of the town. The general public mostly used 'queer' as a derogative, but in homosexual circles it was beginning to be worn with pride.

Advertisements, photo headings or articles in popular newspapers also often fired Hockney's imagination. The work *Sam Who Walked Alone by Night* refers to a story he had read in New York in a homosexual magazine about a boy who sometimes dressed up as a girl. At this time it was still quite brave to 'come out'. 'It was part of me and not often publicly spoken of, so I thought I must do something about it. I was a bit what later became known as "militant", although I never considered myself as militant.' The Gay Liberation Front in England began only in the seventies and homosexuality was still illegal and punishable by prison.

For Hockney the use of graffiti remained a favourite habit adopted from the Cubists. He sometimes juxtaposed the crudeness of graffiti with elevated quotes from poems. A message he had seen on a weighing scale – 'The more effort you put into recreation, the more you enjoy it' – found its way into the painting *Your Weight and Fortune*. The irreverent fun was part of the new

artistic message, expressing his penchant for wit and mischief. Titles and subtitles also forced the onlookers in the direction the artist wanted them to go. The propaganda nature of these early works accounts for the fact that they are sometimes over-loaded with references and information. Some were easily readable, others could be decoded only by those 'in the know': Hockney loved to imbed cryptic messages of a more or less private nature. Like a child, he indulged in the pleasure of conundrums, sometimes to confuse and offend. To this day, riddles still enchant him. When I asked him to unpick some of his for me, he smiled, 'Let's not analyse everything, it's a long time ago, just follow your instinct and what you know, we have both been around a long time and it doesn't really matter any longer. The paintings should be enjoyed for what they are.'

An etching from 1961, *Gretchen and the Snuri*, is filled with messages: 'Gretchen/Aunt Jemima Coffee cake mix with cinnamon topping' and "i t'amo bambino/snurl/snurl.snatch (nasty). They/lived hap/ly ever aft'. The inscriptions were a private joke addressed to Mark Berger and his Italian lover. Mark had written a fairy tale about two lovers, Mark and Gretchen, who lived in a city under a monster called Snatch but were saved by a creature called Snurl. Hockney actually did five small illustrations for it and in one, David advised them to escape the 'nasty snatch' in order to live happily ever after.

But there was also a deeply serious side to Hockney. Behind the camp banter was a tough and shrewd sense of purpose. With his obstinate perseverance, his artistic intelligence always won the upper hand and few people have been able to walk the tightrope between the frivolous and the serious so skilfully. Always eager to learn and to improve himself, he read voraciously and literary sources inspired much of his work. It cannot be a coincidence that so many of the poets he quoted or illustrated were homosexuals – Arthur Rimbaud, C.P. Cavafy, Edward Lear, Michelangelo and Walt Whitman. However much he refutes the notion of the 'homosexual artist', the affinities and empathy are strong.

In the painting *Adhesiveness*, done in his second year at college, are the numbers 4.8. and 23.23. They stand for the letters D.H. and W.W. – Hockney and Walt Whitman. This numerical device was much used by the American poet. The title came also from Whitman, 'adhesiveness' describing the bond between two friends. At first glance, the painting seems almost abstract but closer inspection reveals it to be one of Hockney's most sexually overt works. Two figures are in a 69 position, or they could also be seen as a man inserting his tongue into the mouth of the other while he is penetrated.[9] The message of the painting was certainly bold. It was bought by Cecil Beaton for £40.

Walt Whitman (1819–1892) was the first American poet to openly express homo-erotic longings. He subscribed to a new sexual identity, exalting in the vision of a universal comradeship. Whitman knew much about the darker, self-concealed side of many homosexual men. But his luminous and melancholic poems speak eloquently of the love that still did not openly dare to declare itself. He was 'resolved to sing no songs today but those of manly attachment'.[10] Mark Berger and David had read Whitman together and the poet's demand for the affirmation of an instinctive life struck a deep cord in the young painters.

WITH THE LOVE OF COMRADES,
I WILL PLANT COMPANIONSHIP THICK AS TREES ALONG ALL RIVERS OF AMERICA
AND ALONG THE SHORES OF THE GREAT LAKES, AND ALL OVER THE PRAIRIES.
I WILL MAKE INSEPARABLE CITIES WITH THEIR ARMS ABOUT EACH OTHER'S NECKS.[11]

To this day David still quotes these lines. When Hockney began to make prints in 1961, his first etching, *Myself and My Heroes*, shows him in the company of Whitman and Mahatma Gandhi. The sex-affirming American poet and the ascetic Indian leader were rather an odd couple. He had chosen Gandhi because of his humanitarian message and his vegetarianism, and by

placing himself with these two proclaimers of love among men, Hockney declared his own aspirations. In this homage to his two 'heroes' Hockney appeared touchingly modest; the two are crowned by a halo, while he wears merely his student cap. His caption reads: 'I am a 23-year-old and wear glasses' while that on Whitman cites the line 'for the dear love of comrades':

TO TELL THE SECRETS OF MY NIGHT AND DAYS,
TO CELEBRATE THE NEEDS OF COMRADES.[12]

In *Leaves of Grass,* published in 1860, Whitman had grouped some overtly homosexual poems under the heading *Calamus.* The title derived from the Greek calamus, meaning 'beautiful', and Calamus the son of the god of the river who fell in love with the boy Carpus. When his lover drowns accidentally, grief-stricken Calamus is changed into a reed. Calamus contains one of the greatest love poems of the nineteenth century: *When I Heard the Close of the Day.* David was especially fond of it and he inscribed its closing lines in his *Third Love Painting*:

'FOR THE ONE I LOVE MOST LAY
SLEEPING BY ME UNDER THE SAME
COVER IN THE COOL NIGHT,
IN THE STILLNESS IN THE AUTUMN
MOONBEAMS
HIS FACE WAS
INCLINED TOWARD ME,
AND HIS ARM LAY LIGHTLY AROUND
MY BREAST, AND THAT NIGHT
I WAS HAPPY.'

The romantic and elevated lines share the canvas with vulgar graffiti. At first glance this painting too looks almost abstract, but nearer inspection reveals a huge red penis in front of a glory hole, and the messages that are passed

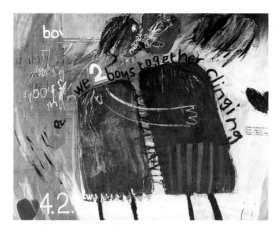

WE TWO BOYS TOGETHER CLINGING, 1961, OIL ON BOARD

through it. The sublime shares the canvas with the vulgar. Cottaging messages such as 'Must go', 'My brother is only 17', 'Britain's future is in your hand' or 'Ring me any time at home' are scrawled over the canvas. The word 'love', so prominently displayed in the earlier 'Love Paintings', is now small and smothered under obscenities. The line 'Come on David admit it' is the honest statement of an artist who no longer wants to hide.

Another Whitman poem, *We Two Boys Together Clinging*, inspired Hockney in the same year to produce a five-foot oil painting on hardboard, much influenced by the work of Jean Dubuffet. Whitman's title is written across the necks of two figures embracing, the lettering tying them together. For the right-hand side Hockney chose the lines, 'Power enjoying, elbows stretching, fingers clutching,/ Arm'd and fearless, eating, drinking, sleeping, loving.' On the lips of one of the boys are the words: 'Never', the lover's oath taken from the line: 'One the other never leaving'; the other is replying 'yes'. In addition to these more obvious messages are more private ones. The number 4.2 next to a heart stands for D and B, David and 'Doll Boy' – Cliff Richard. There was also another title inscribed in the painting. It had come from a recent newspaper headline

referring to a mountain accident, 'Two boys cling to cliff all night long'. It had greatly amused David. The reference to 'doll boy' continued. In an etching, *Alka Seltzer*, a naked boy in a transparent dress is being watched by another figure. The boy is D.B. (Doll Boy) and is labelled 'the most beautiful boy in the world'. This theme is again taken up in a painting *The Most Beautiful Boy in the World,* of which there are two versions. One depicts the image of two nude boys embracing David (identified by the figure 4.8.) and D.B. In the second picture, the two figures stand so close that they almost form one. There is also the image of a heart and the inscription 'D boy' plus the figure 69, as well as messages such as 'I love wrestling' and 'C.U'. On this picture another name also appears: 'Pete' and the figure 16.3. (P.C.) This is a reference to Hockney's fellow student, the heterosexual Peter Crutch, who David rather unsuccessfully courted. The most beautiful boy could be either Cliff Richard or Peter Crutch, both unavailable. The word 'never', written in Hockney's *We Two Boys Clinging Together* takes on the meaning of the impossibility of love. David and Peter, always known as Peter C., became friends. In his etching, *Mirror, Mirror, on the Wall*, Hockney asks the question: 'Mirror, mirror on the wall, who is the fairest of them all?' And he gives the reply 'Peter' who had begun to figure in many of Hockney's work.

On Friday nights in the bar of the Royal College students used to dance and, David claims, boys sometimes danced together. *The Cha-Cha that was Danced in the Early Hours of 24th March* was the title of another painting of 1961, based on Peter who David had watched dancing while holding a girlfriend's handbag. The picture shows him in front of a mirror with the highly suggestive lines: 'Penetrates deep down' and 'gives instant relief', a slogan for an ointment. This sort of advertisement always reduced David to hilarity and brought out his schoolboy naughtiness. There is also a watercolour *Hero, Heroine and Villain* in which the hero, 16.3 (Peter), is embracing his heroine while 4.8. (David) looks on.

It has always been difficult to engage David in any serious discussion about his love or sex life. It still is. He does not mind breaking taboos but he shies away

from public revelation. To gather information about how David feels, one has to look into his work, much of which in the sixties were investigations into his own sexuality. Some celebrated love, but many also hinted at his inkling of the futility of it. In 1960/61 Hockney had done four 'Love Paintings'. The first is almost abstract with a large phallic shape filling the left side of the canvas. Only the words 'suspicion', 'love' and 'sperm' hint at a more direct message. In the *Second Love Painting* the shapes of a phallus and a heart are linked by the word 'love'. The *Fourth Love Painting*, also titled *The Last Of England?*, has two figures embracing. The figure on the right carries a heart and the number 4.8. (D.H.). The other figure is not identified. Above the two is the message 'I will love you at 8pm next Wednesday'. This imitates a line from W.H. Auden: 'I will love you at 4.15 p.m. next Tuesday'. Both Hockney and Auden tell us that sworn love is not eternal.[13] The passing of love, especially physical love, is further emphasized by the figure 69 in the left-hand corner of the painting. Painted after *Doll Boy*, the word 'Valent', referring to Valentine, is scrawled in large letters on the canvas. The four 'Love Paintings' are a clear indication of how, for Hockney at that time at least, love and sexual impulse were closely related.

Hockney's early paintings were rather flat. David usually just drew the outlines with a pencil or a brush and later filled in the colours. The often cartoon-like characters had an energy and freshness that later works sometimes lack. His work gave ample evidence of his extraordinary drawing skill, but what is so amazing is that as a painter so formed within the teaching of perspective and the precise rendering of the body, he had invented his own language.

Many people thought that these childlike and deliberately crude scribbles were mere camp whimsicalities, a kind of false naivety: 'Many people at college sort of looked down on me.' It was not the subject that shocked them, but the traditional approach, although his work was far from conventional or realistic. Some thought it was 'junk'. One day the painter Richard Hamilton came to a sketch class and gave out a student prize of 'a couple of pounds' which Kitaj

and Hockney won. From then on, Hockney claims, people looked at him with more esteem. David also began to meet other painters, among them Peter Blake and Joe Tilson. All this gave him more self-esteem and prompted him to produce a lot of work, sometimes having to paint over old canvases as he hadn't enough money to buy new ones.

Homo-erotic references increased in Hockney's paintings, sometimes subtle, hidden, and often carefree in their playful attitude to sex. David was much impressed by the nude bodies he had seen in an exhibition of paintings by Francis Bacon, and he went around telling everybody that they were so sensual 'that one could smell their balls'. One of his own paintings, *Figure in a Flat Style*, clearly hints at masturbation. The hands touch the genitals and the line, 'the fires of furious desire', taken from William Blake and written on the canvas, underlines the theme. The subject is also treated in an etching with the title *Fires of Furious Desire* and the word 'love' written on it. Lavatory graffiti messages also became titles of his paintings, as in *Oh For a Gentler Lover* or *My Brother is only 17*, an inscription he had used in *The Third Love Painting*.

The Third Love Painting, *Doll Boy* and two *Tea Paintings* were exhibited in the annual RCA's exhibition, 'Young Contemporaries' of 1961. It showed mostly works of students from the Royal College – Hockney, Derek Boshier, Patrick Caulfield and Ron Kitaj. The exhibits, however different, shared a confident, defiant mood, challenging the mandarin taste of the establishment. Many had used images of popular culture to find new visual experiences, which earned them the title 'pop artists'.

Hockney became associated with 'Pop Art' – a label he has never been able to shed totally. His way of meshing different media together, many from popular non-art sources such as Typhoo Tea packets, made him an obvious candidate. Richard Hamilton had first used the term in 1957 for an art form that was, according to him, 'popular (designed for mass audiences), sexy, gimmicky, glamorous and big business, colourful, energetic, looking to

America rather than to England'. But David never liked this label, despite some of Hamilton's definitions applying to his work. He was reported to have shouted at one of his shows, 'I am no pop artist.' 'Schools of paintings,' he often said, 'are the products of American arts pundits, who from time to time decide where art should go.' At the time a young BBC television producer, Ken Russell made a Monitor programme called, 'Pop Goes the Easel'. The programme included the works of Derek Boshier, Peter Blake, Peter Phillips and Pauline Boty, but David refused to be a part of it. However, if one watches carefully, David can be spotted dancing the twist in a golden jacket. He looks like the brightest star in a bright generation.

The 'Young Contemporaries' exhibition also brought David his first dealer and a lifelong friend, John Kasmin, always known as 'Kas'. Kas was really a poet but in order to make ends meet he worked in various London galleries. In 1960 he was the manager of the Marlborough Fine Art Gallery in Bond Street. A friend of his, the young Marquis of Dufferin and Ava, was considering helping him financially to open his own gallery for contemporary British artists. Kas went to the 'Young Contemporaries' show and with sure instinct bought Hockney's *Doll Boy* for £40. It now hangs in a museum in Hamburg. Kasmin tried to get Marlborough interested in his new discovery, but without great success, so he took Sheridan Dufferin to meet David and another friendship was struck. When Kas left Marlborough he first showed Hockney's work in his flat in Earl's Court, selling the paintings for £50 to £100. The drawings went for about £10.

While still a student, Hockney collected several prizes. He won the painting prize in the Junior section in the John Moore's Liverpool exhibition, the Guinness Award, and the first prize for etching at the Graven Image Exhibition. He was on his way to fame. His early success and colourful lifestyle not only made him stick out from the rest of the students, but it also earned him the name 'the golden wonderboy'.

New York, here I come

In 1961 with the money he had made from his work sold at the Graven Image Exhibition in 1961 and a £40 airline ticket that had been given to him, he decided to go to New York. With its myriad contradictions, the delicious mixture of ignorance and sophistication and the coexistence of the disreputable with the most puritanical, New York was for many young homosexuals the mecca of sexual freedom. David too was terribly excited and for weeks before he left he talked about nothing else. And then in the summer he was off with £200 in his pocket and, David being David, a number of his etchings taken along as well.

New York lived up to his dreams. He stayed with Mark Berger in his parents house in Long Island and shortly after encountered his all-American boy in a drugstore on Times Square. He moved in with the painter and photographer Ferril Amacker. Ferril was very outgoing and took the still-shy David to the gay bars of New York. David also went to the Museum of Modern Art and sold some of his etchings to the-then director, William Lieberman for $200. MOMA thus acquired their first Hockneys, *Kaisarion* and *Mirror, Mirror on the Wall*. All this put him in high spirits, and he made an etching showing himself on top of a skyscraper waving a big American flag; he called it *My Bonnie Lives Over the Ocean*. The Bonnie was Peter as the letter P on the second figure indicates.

Hockney returned to London in the autumn with sketchbooks full of drawings and copies of *Physic Pictorial* magazines which, in England's still puritanical climate, were impossible to obtain. The American magazine was a terrific turn-on for many young men in England and gay artists such as Keith

Vaughan, John Minton and Mario Dubsky used it for inspiration. The presentation of strong muscular men had been the concern of body and health manuals since the beginning of the century. Fifty years later, with television in its infancy, and video tapes unheard of, these manuals were almost the only source of gay sexual stimulation in print. Most athletic magazines in the fifties were afraid of offending popular taste. Any hint of homosexuality had to be kept at bay and sexual ambiguity was still the order of the day. They showed a world of sports arenas, locker-rooms and male camaraderie. There were plenty of back views, but no cocks. The often padded pouch, known as a posing strap, was part of the attraction. The magazines David brought back from New York were different. The photographs of the fifties still had a kind of innocence, but the sixties' magazines published the first frontal male nudes. The merit of these magazines were that they openly disregarded any of the false moralizing attitudes of the past. The naked man was shown in photos and paintings for what he was. Physique magazines, which for so long had disguised their nudity under the mantle of health and the love for nature, were now openly aimed at the homosexual reader and came out in praise of the naked male. Gone were the coyly brushed-out genitals. The physical athlete, the beef-cake that exploded on the scene, wore a knight's helmet or cowboy boots. There were plenty of naked men leaning on motorcycles or climbing up scaffolding, wearing nothing but a helmet. *Physic Pictorial* and similar magazines offered everybody a bit of sunlit and sun-tanned California, but it is ironic that these photographs, treasured because of their 'nearness to life', presented images that were far from 'real'. The tanned and oiled surfaces had simply replaced the marble and bronze of the past. In the muscle-flexing bodies of heavy-crotched men, bursting at every seam, a new homo-erotic type was developed.

The device of using magazine images was widespread among young painters. In 1957 Richard Hamilton had used cut-out figures from muscle magazines for his painting *Just What is it that Makes Today's Homes so Different?* It

depicted a nude male stripper and his girlfriend among the mass-produced clutter of their home, an invitation to a fabricated dream we are all allowed to share. The magazines David bought back quickly made the rounds among his friends and David himself was terribly turned on by them. Not that he cared much for what he called the 'big butch scabby' types; his taste in men has always been for 'the pretty boy'. There is ample evidence in his work of that. He is not really turned on by sexual prowess; his life is lit by a sensual *pudeur*, a tender admiration of the beautiful. But these magazines continued to serve him as inspirations for his work nevertheless.

During the sixties the public attitude towards nudity rapidly began to change. It was seen as another act in defiance of convention, a claiming of freedom, which permeated not just the gay world, but all of youth. It is difficult to imagine nowadays the joy and the social importance of seeing naked actors in the musical *Hair* and in David Storey's play, *The Changing Room*. An entire rugby team in the buff on the stage at the Royal Court Theatre was something we did not easily forget. The borderline between art and pornography was constantly shifting.

David is no prude, and he does not hide his pleasure in watching pornography, now vastly 'improved' on video tapes. The mixture of the exciting and the faintly ridiculous appeals to his taste and sense of humour. He has been involved in the long battle with those who want to destroy pornography: 'We all know that we would not destroy anything, no matter how pornographic, if it were five hundred, or a thousand years old; we would regard that as irresponsible because we want to study that material, we would want to know whatever it told us about what people were thinking, what people were seeing.' He knows that in the history of ever-shifting ideas of what constitutes pornography, it too has a vital part to play if one wants to understand humankind.

He openly rejoices in the fact that men are nowadays allowed to look at other

men in the nude outside of the context of high art. Hockney has consistently used muscle magazines in his work. He has written about their influence and has kept a large collection of 'gay mags' in the hopes that one day he can make an exhibition of them as an example how 'camera and printing developed from single figures to groups and finally close-ups of sexual details'. Hockney often complains about the hypocrisy of a society in which generations have grown up with the nude statues of antiquity, but were not allowed to look at a naked man in a photograph. 'We live in a world determined by heterosexual taste which dictates that the body of the man remains clad. Among most people the nude male, and with it his availability, is still taboo.'

When he returned to London after three months in New York, there were several visible changes in David's appearance and in his work; not only was he now blond, but he had left behind him that phase in his work of open sexual messages. It was the end of his most 'unbuttoned' pictures, his 'sign-off' perhaps being one of the records of his American experience, *I'm in the Mood for Love*, in which he shows himself as a devil wedged between two phallic skyscrapers, and jokingly using the subway sign 'To Queens Uptown'. Homosexuality did not cease to be his inspiration, but its appearance was no longer so blatantly obvious.

The major work that ensued from Hockney's first visit to New York were the illustrations based on William Hogarth's sequence, *The Rake's Progress,* first published in 1732. It is the tale of a young man who squanders his inheritance and is condemned to madness and poverty. The appeal of the story to Hockney was not surprising. By transporting it into modern times, it allowed him to use it as a laudation and a critique of a world of almost unshakeable belief in the right to happiness and pleasure. His illustrations grew out of his private experiences in New York, a 'modern city of mindless and inhuman capitalism'. However seduced by what he saw, his inbuilt feeling for social justice did not make him blind to the blatant inequalities he witnessed.

Hockney worked on the series for two years, doing about fifty etchings, most of which he rejected. It took him another trip to New York in 1963 to finish the sequence. The final sixteen aquatint etchings in red and black hint at the seduction and danger of the new world he had found. The first shows David the Rake arriving in New York and gazing at the skyscrapers. The earlier sale of his etchings to the Museum of Modern Art is recalled in *Receiving an Inheritance*. It shows David looking on rather sadly as a stern collector carries away his work, marked $20, for which he seems to be offered only $18. Soon after arriving in New York, David had bought himself an 'American suit' and dyed his hair. Both events are recorded in two images, *The Start of the Spending Spree* and *The Door Opening for A Blonde*. The last one cites the advertisement for Clairol – 'Blondes Have More Fun' – the hair dye he had used. In other etchings he hints at his experience with the gay world. In *The Election Campaign (with Dark Message)*, he jokingly recalls the election day when the gay bars, indeed all bars, were closed. The dark message on the canvas reads 'Bar closed'.

Hockney loves the idea of print-making, not least because of the infinite possibilities of bringing the world into the homes of many. He has often talked about 'how art affects our way of seeing the world, and how this in turn affects the way we depict it'. The wide distribution of artistic images through print-making, he always thought, might help us to 'see the world a bit clearer'.[14]

In the sixties and seventies prints were big business. With oils and drawings priced out of the reach of most people, the sale of artists' original prints increased tremendously. Paul Cornwall-Jones from Alecto, a new print gallery, paid him the staggering sum of £5,000 for his sixteen etchings for the *Rake's Progress*. Hockney and his friends thought he was joking.

Whenever he could afford it, David went abroad. He has always been a great traveller, and the need for escape has never left him. He frequently likes to

interrupt the flow of his life in order to recharge his batteries and look for inspiration elsewhere. This, and an inbuilt curiosity that has sometimes led him into things unplanned, have prompted him to move numerous times. In travelling he has always discovered a different perspective on the world which challenged the way he had perceived things before.

In 1961 when Mark Berger was studying in Florence, Ferrill Amacke came over from New York and he and David decided to go to Italy. A friend offered them a lift in a van. They drove through Switzerland where David hoped to see the Alps in a sort of misty Gothic gloom. But he had generously offered the front seat to Ferril, and from the back of the van he never saw a thing! But when he came home he got out a geography book and painted *Flight into Italy – Swiss Landscape*, showing himself trying to catch a glimpse of the mountains. This little anecdote shows his deep concern that those around him should have a good time and that anything can be turned into a painting.

The chief reason for this journey to Italy was to deepen what he called his 'permanent affair with the art of the past' and 'like all affairs, it goes hot and cold'. From an early age, he had been fully aware that the art of the past offers 'a great diversity that can be put into your own art'. He has never forgotten how little was available to him in Bradford, and later never ceased to remind students how privileged they were, 'with so much knowledge at their disposal in books and magazines and even on television. All things that can filter into your work.'

In 1962 David was due to graduate from the Royal College of Art, but there were murmurings that he might not receive a diploma as he had not done enough life painting. The curriculum demanded that the students did at least twelve life paintings a year but, as always, David hated restrictions other than those imposed by himself. However, to prove his skills, Hockney painted five of his fellow students with their heads bowed down under the principal teacher. He also painted the image of a muscle boy with a posing pouch.

Copied straight out of *Physic Pictorial*, the magazine's title was written in large letters above the figure. Next to the nude man, he stuck one of his drawings of a well-observed and accurately drawn skeleton. He called it *Life Painting for a Diploma*. And just in case he was not to get the diploma, he etched his own on to it. In fact, he passed with flying colours, winning the 'Royal College Golden Award'. To collect it David wore a golden lamé jacket instead of the traditional academic gown. To thunderous applause from his fellow students he carried his medal off in a flight bag.

David kept on telling everybody how rich he now was, and by most student's standards this was certainly true. He had a small scholarship and Kasmin guaranteed him an income of at least £600 a year. His paintings sold now for £50 to £100. And in what became a pattern, David started to pay for everybody, his generosity almost as legendary as his work.

DOMESTIC SCENE NOTTING HILL, 1963, OIL

At the foot of the bed he had written in large letters,
'Get up and work immediately'

A bit of America in Notting Hill Gate

For a while David shared a flat with the singers Rod Stewart and Long John Baldry, but in 1962 he found his own flat behind Notting Hill Gate in Powis Terrace. Close to the Portobello Road market, it was not then a very fashionable area. This was really the first time that David had had a proper place to himself. The rent was just £5 a week for what he described as a large flat. It consisted of two rooms, one small and one large in which he painted and slept. Compared to the minute digs he had so long occupied in Earl's Court, it seemed lavish. The furniture consisted of a small bed and a chest of drawers. Later a sofa and a few chairs appeared. At the foot of the bed he had written in large letters 'GET UP AND WORK IMMEDIATELY'. The first thing he saw when he woke up, it's a motto he has followed all his life. Many paintings in various states lined the walls, as he was in the habit of working on several canvases at once.

The flat was located on the first floor of a Victorian terrace house; from his 'desk' he could see the street and 'watch ladies gossiping at the dry cleaners'. Hockney has always been an insatiable observer of ordinary happenings. Painter friends Derek Boshier and Peter Blake had studios nearby, Mike and Ann Upton lived around the corner, and people always just dropped in. Although he craved solitude when at work, David's social life has almost always been made up of a large group. In the crowded family home in Bradford, it had not been unusual for there to be seven or eight at the dinner table, and this had set the pattern for the rest of his life. All his homes were marked by a feeling of conviviality and camaraderie. He is socially gregarious and the telephone never stops ringing. Sometimes he changes his number, but before long people have the new number, mostly given out by David himself.

David is always courteous, often affectionate. He likes to say 'yes' and to give pleasure, and as a result he is often too kind and generous with his time. But Hockney remains the master – it is always his heart and mind that determines the domestic and working rhythms and the rites that solder friends together. He is the holder of the keys and everything turns around his person, has to be at his disposal. And the mood can suddenly shift; anger, if things do not go his way, can suddenly well up, and he can be petulant. He is selfish, as most artists are and have to be in order to achieve what they set out to do, and those who do not understand this suffer. I have rarely known such discipline as his. His constant fight has been to create enough space for himself and his work in an ever-spiralling schedule. Work has been his coat of armour in an increasingly public life.

America continued to influence his lifestyle and work. He installed a shower in his flat and showers became a favourite subject. Over the next few years they were increasingly the settings for Hockney's snapshot-like paintings. In Europe, showers were associated with schools and sport centres. For many European men, they meant a communal activity, the gathering of naked men, soldiers, sportsmen. Nude men bathing together had long been a familiar artistic theme, from Michelangelo to Cézanne. The buddy feeling with its erotic potential appealed to many. A drawing from 1963, *American Boys Showering*, shows two boys taking a shower together. 'Americans take showers all the time', David announced, and described the many showers he had seen, with glass doors and curtains made of all sort of materials, some of it transparent. Most of his friends laughed about his long description of the American bathroom, 'with fluffy carpets and pink towelling on the lavatory seats.' Like so many English, David had been used to one bathroom per house, usually tucked away at the end of an ice-cold dark corridor, as though not part of the house, and slightly embarrassing. Many working-class houses did not even have that and the outside 'privy' was not uncommon. 'In America they have what they call "bathrooms en suite"': Hockney's refreshing disingenuousness, his fertile imagination, and the natural raconteur

always came to the surface to express his amusement. A print, *Cleanliness is Next to Godliness*, depicts a rather silly, smiling handsome hunk of a man looking through a transparent shower curtain. He is being watched by a frog. But the attractiveness of painting men in showers for Hockney was not simply a voyeuristic one; it excited him as a painter. 'The whole body is always in view and in movement, usually gracefully, as the bather is caressing his own body.'[15] There are many colour and pencil drawings of Mo and other friends in the shower, often inspired by photographs from American physique magazines.

In the summer of 1962 David travelled with an American, Jeff Goodman, to Munich and Berlin. He had met the very handsome Jeff in London and they had what David calls 'a little fling'. And as so often, David's flings turn into friendship. Jeff was a paper maker and later David sometimes stayed with him in New York. The trip to Berlin was another pilgrimage to homosexual desire. David had read Christopher Isherwood's *Goodbye to Berlin*, which describes the carefree time that he, Stephen Spender and W.H. Auden had had there in the early thirties before Hitler put an end to all that. Berlin is also my home town and I was eager that David have a good time, so I had given him the address of the famous Kleist Casino, an old-fashioned club where men danced together under pink lampshades.

Although David came back rather disappointed not to have met Isherwood's friends, Sally Bowles or Fritz and Rudi, who used to bathe naked in the lakes, nevertheless Berlin was a success. 'I spent most of my time in museums and at *Wurststands* (sausage stands).' With his usually carefree enthusiasm and natural curiosity, his description of gay bars were as wonderfully vivid as those of the pictures he saw in museums. The painting, *Picture Emphasizing Stillness* features two nude boys holding hands, one a 'Berliner' and one a 'Bavarian'. A lion, an image of which he had seen in the Pergamon Museum, jumps from the sky, threatening the boys. But any danger is diverted by a line Hockney has put on the canvas: 'They are perfectly safe. This is a still.' The

play with words, the double irony is obvious. The painting also shows another hallmark of Hockney's nudes – the accent on the bare buttocks, often emphasized by a tan line. A tan line, for many people, is more suggestive than an all-over brown body. A sexual tease, it suggests that the sitter has only taken his clothes off for the artist and the onlooker, thus increasing the intimacy of the act.

The feelings of friendship, of male complicity, of emotion and/or sexual commitment now became a frequent theme in David's work. His longing for companionship, for sharing, for the knowledge of how two men can love and care for each other, is reflected in the many intimate, domestic scenes which reflected the relaxed and casual atmosphere of his flat. *Domestic Scene, Notting Hill Gate*, one of a series of 'Domestic Scenes', shows two of his friends, Mo naked, standing on the bed, and Ossie dressed, sitting in a large armchair. The mixture of a nude and a clothed man gives it an added erotic touch. Another picture of domesticity showed his painter friends Joe Tilson and Peter Phillips.

Many of Hockney's pictures were the result of acute observation of his environment. The lamp and a large vase with plastic flowers which appear in the paintings actually stood in his flat, but the people are frequently stylized in ways that make recognition difficult. The paintings were not meant to be real portraits, nor are the objects accurate renderings of his flat. They were imagined scenes in which only one or two elements conformed to the artist's actual life. Hockney always tries to tell a story, and the people and isolated objects often conjure up a world he imagines.

On the road to stardom

Hockney's rise to public acclaim seemed to be unstoppable and it amazed his friends, more than it did him. His innate optimism always came to the surface and left him almost free of the usual artistic angst. 'I am a very practical person. I do not want to waste time on something which I cannot do. I follow my instinct; on the whole it has not let me down. I am sometimes side-tracked in my life and in my art, but I always come back to what I really am . . . I don't plan too much ahead about what one is going to do, I assume as you go through life that certain things, as it were, take care of themselves.'[16] Fear of failure is not part of his psychological make-up, although he knows doubts and he recognizes the impossibility of creating wonderful work all the time.

By 1963 Hockney's reputation was established: both the public and the critics had taken notice of the bright new star. All the major newspapers had given him high praise, pointing out his freshness of vision and his masterly lines. His paintings were included in several shows and he, Boshier, Blake, Jones and Phillips were chosen to present the new British painting at the Paris Biennale at which Hockney earned a prize for graphics. A photo shows them there, all except for David dressed in dark suit and tie; David is wearing a loudly striped open-neck shirt under a light jacket. Pictures of Hockney appeared frequently in the press. The love affair between Pop Art and the media lasted for years, and David was a master in manipulating and promoting his public image, which he did with outrageous grace – and he never disguised the pleasure it all gave him.

He had inherited his father's fastidiousness in dress, but he outdid his

eccentricity. Wearing round, black-rimmed glasses like Le Corbusier's, he was photographed in colourful sweatshirts with large inscriptions, or in a bright red cardigan, smoking a cigar. Lord Snowdon photographed him going shopping in his gold jacket with matching shopping bag. It was not long before he became a favourite of the glossy magazines, together with pop singers, fashion models, decorators, film stars and dress designers. In the past, those who made the glossies were mostly chosen for their class, fame and money, but the idols of the sixties were picked because of their youth, their sexually liberated attitudes and supposedly classless backgrounds. Hockney was seen next to Rudolf Nureyev, Mick Jagger, Jean Shrimpton, David Hicks and even the infamous Kray Brothers.

In a portrait of him by Peter Blake, we see a bewildered-looking creature, surrounded by yellow balloons, streamers, confetti. *Homo ludens*, the man as a player, he learned from Picasso. Playfulness, as he often stated, is a way to discovery, to surprises. A look at Hockney's early hedonistic work and life is also a look at the climate of London in the sixties. The search for pleasure stood high on many people's agenda. Hockney's rapid rise to fame, like that of the Beatles, showed that for the first time, to be young, working class and from the provinces was a ticket to success. 'These young artists from the provinces bring to London a built-in edgy, sceptical intelligence and a particular awareness of fashion and "what's in the air", which gives at once an extra drive to their work and a marked irreverence towards prevailing standards and aesthetic issues,' wrote the influential critic, Bryan Robertson.[17] Headlines such as 'Hockney the Sixties Swinger', 'The Artist Who is Lovable and Cuddly', 'Top of the Hips', 'Hic Haec, Hockney' or 'David Hockney – No Dumb Blond', made him laugh. David took it all in his stride, loving it and, with his usual innocence, not even noticing that the 'serious' art world did not take too kindly to such behaviour, sneering at his success and accusing him of shallowness. Artists, in order to be taken seriously had to be doubting, struggling, miserable, unattractive, and not too successful – and Hockney was none of these. He is well aware that the enormous public interest in his

colourful lifestyle, focusing on the man rather than on the artist, has often overshadowed the seriousness of his art. But whatever the criticisms laid at his doorstep, he became the hero of a new generation, and to this day he more than any other British artist represents the spirit of the sixties.

In 1962 London's *Sunday Times* introduced its colour supplement, edited by the brilliant caricaturist, Mark Boxer, who had been the editor of *Man About Town,* and the art critic, David Silvester. One of their schemes was to send artists to different places, asking them to catch the spirit of the place and become a personal *genius loci.* They wanted work from Hockney, and the obvious choice of place was Bradford. David always loved his home town, but he had no inclination to go there on such a prestigious assignment. His idea was rather more exotic – he persuaded them to let him go to Egypt. He bought a fetching white suit and had himself photographed with a suitcase in his hand, wearing a white cap and a polka-dot bow tie. And then he was off.

He travelled for three weeks, visiting Alexandria, Cairo and Luxor. He had for a long time been interested in Egyptian art, admiring what he described as its 'rigidity'; an exercise in painterly discipline and anonymity. The possibility of remaining anonymous behind a work of art was intriguing for a painter so much in the limelight. Hockney returned with a suitcase full of colour crayon drawings which were more concise, more detailed than anything he had done before. Ironically the *Sunday Times* did not use any of these delightful and very free scenes. His work was pushed aside by President Kennedy's assassination.

As art was one of the commodities the newly affluent wanted to buy, many new galleries had opened in the sixties. London listed over one hundred. Leslie Waddington and Robert Fraser opened new premises for younger artists, and so did Kasmin. The posh Fisher Fine Arts Gallery still thought Hockney was 'junk' but in December 1963 Kasmin gave Hockney his first one man show. It was called 'Paintings with People In' and included ten paintings and many drawings. The critical reception was enthusiastic and all

the work sold. Hockney, aged twenty-six, had already arrived in Bond Street. The sale had made him a couple of hundred pounds.

In May 1964, the director of London's Whitechapel Gallery, Bryan Robertson, organized a pioneering show, 'The New Generation'. In previous years, the enterprising Robertson had begun to mastermind a number of important exhibitions and had turned this gallery in the working-class East End into the most interesting place to see new art. He brought to London the cream of American art, including works by Jasper Johns, Willem de Kooning, Jackson Pollock and Mark Rothko. He had also put on retrospective exhibitions of post-war English painters such as Keith Vaughan, Robert Medley and Prunella Clough. Now it was the turn of the younger generation.

The first 'New Generation' exhibition came as great surprise. 'As well as providing what I hope will be a beautiful and revealing spectacle for the London public, the exhibition gathers together for the first time in a clear-cut way twelve artists whose work is conspicuously brilliant and gifted,' Robertson wrote in the catalogue. David Hockney, Patrick Procktor, Bridget Riley, Allen Jones, Derek Boshier, Patrick Caulfield, Paul Huxley, Peter Phillips, John Hoyland and Anthony Donaldson, a formidable choice, were brought together in a single exhibition. Most of them, although barely out of college, would soon have an international reputation. Some, like David, had already achieved this. The photograph of an artist's studio for the cover of the catalogue was by Lord Snowdon, and at the private view most of artistic London was in attendance. The arts pundit and at that time television director, Jonathan Miller, reviewing the show, wrote, 'There is now a curious cultural community, breathlessly à la mode, where Lord Snowdon and the other desperadoes of grainy blow-ups and bled-off lay-outs jostle with commercial art-school Mersey stars, window dressers and Carnaby pants-peddlers. Style is the thing here – Taste 64 – a cool line and the witty insolence of youth.' But it was much more than this. It was in fact an art of

splendid pluralism, self-confident and challenging. For the first time English art had escaped its provincialism and seemed able to bear comparison to the richness and formal invention of the New York art scene.

The sixties seems, retrospectively, to have been a collective dreamtime of great all-embracing new art and newly gained sexual freedom. In fact, as too often, only a handful of people in England recognized the significance of the exhibition. I had made a note of the asking prices of the paintings: for £65 you could have bought an oil by Patrick Caulfield, for £100 a Bridget Riley. Hockney's *The Hypnotist* was priced at £225. For the catalogue the artists were asked to write a short essay about themselves. Hockney simply stated: 'I think my pictures divide into two distinct groups. One group being pictures that started from, and are about, some technical device and the other group being really dramas, usually with two figures.'

By the time this influential exhibition closed Hockney was already living in Los Angeles. In 1963 he had decided to go there in search of colour.

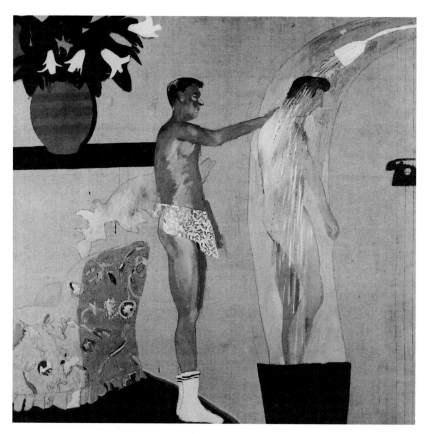

DOMESTIC SCENE, LOS ANGELES, 1963, OIL

'Americans take showers all the time'

In search of colour

Ever since his visit to New York, Hockney yearned to escape what he called the 'Englishness of English art', marked by dark colour, detachment and reticence. 'I don't know why English art is so gloomy. We once had pictures with a blaze of colours. Think of Holbein's rendering of the court of Henry VIII. Here was a painter who looked hard and then gave us a picture of a generous spirit. I like an art where the eye is at work, delighted.' The man talking to me sits on a bright red chair in a room painted bright blue, looking out onto a sunlit deck painted in the same primary colours, the colours of his Californian home for the last thirty years. Nobody could have predicted this major move at the beginning of 1964, when he arrived in Los Angeles for the first time, least of all David. But right from the start he was attracted by the directness, coolness, even garishness of American art. He had first learned about contemporary American artists through the Penguin Modern Art series he had bought as a student in Bradford: 'I thought people who produced such work must live in colour, so I went in search of it.'

Of the many places Hockney was to visit in the next thirty years, it is California that has had the strongest and most lasting affect on him. 'I had spent the first twenty years of my life in the gothic gloom of the North; here I felt free.' In his own words, he was more 'thrilled' here than in any city he had ever been. Hockney loved everything about Los Angeles – the vast expanse of the sprawling suburbs, the whimsical houses in every possible style hovering over manicured, tidy lawns festooned with sprinklers, the pools with their possibilities of nudity, the large cars that endlessly cruised the long avenues bordered by palms which seem to touch the sky. The boulevards stretched for miles and had names like Hollywood, Sunset, and Santa Monica.

It all looked, in his own word, 'glamorous'. For many people, pools and lawn sprinklers are far from glamorous, but for the visitor from London, Los Angeles was a 'glamour place'. He settled effortlessly into the new landscape and lifestyle, and proceeded to capture much of it in his new works.

His fascination with the world of make-believe has never worn off. Many times in the years to come, driving along Sunset Boulevard, he would point out the houses of the great stars with an air of mocking admiration. Tudor mansions, Rhine castles and Roman temples were all part of the dream factory. The faked houses, as insubstantial as the dreams they were modelled on, were an obvious delight to him. 'This is theatre; everything and everybody here pretends to be something else... all fake, nothing is real here.' His delight in artifice, so evident in his work, was confirmed here in concoctions of plaster feigning to be brick or wood. Nothing is what it seems to be.

Right from the start he loved the city and he was determined it would love him back. It is not surprising that it was Los Angeles that eventually turned him into the glamorous star of his later years. Hollywood has always craved and created stardom and Hollywood and Hockney suited each other.

When David arrived, he did not know a single soul, although his reputation had preceded him. What was worse, he did not know how to drive. He installed himself in the Tumble Inn Motel in Santa Monica and got hold of a bicycle. The figure of a blond young man in baggy trousers with a baseball cap riding a bicycle must have been a surrealist sight along the large and motor-clad avenues. But of course in California, as he soon discovered, most problems were quickly solved: 'The moment I got here, within a week, I'd got a driving license, bought a car, got a studio and got a living.'

'It was so sexy, all these incredible boys, everybody wore little white socks.' He fell in love with the clear skies – 'it is always sunny. It's got all the energy of the United States with the Mediterranean thrown in. In cold places half

the time is spent in keeping warm.' For someone brought up in relative poverty, 'where one could afford to heat only one room', this was paradise.[18]

Los Angeles was as colourful and fancy-free as he felt inside. The first month was a time of sexual exploration. He combed the city as if in search of nutritive ingredients, some secret potion. It had a great liberating effect on him. He had read John Rechy's novel, *City of Night*, one of the first honest accounts of the gay life in America's cruise bars. A large section of it dealt with the gay sub-culture in Los Angeles, some of it centred on the area of Pershing Square. Hockney did a painting called *Pershing Square*, hardly needing John Rechy to show him the liberating side of the place. He cheerfully remembers a visit to a sleazy, rather tacky bar in downtown L.A., 'full of Mexican queens'. Something about it reminded him of Cavafy's Alexandria, 'a world of dark alleys, where women would not walk'. He also went to the office of *Physic Pictorial* to buy a lot of stills. He cheerfully described in his letters to London this incredible place with a swimming pool surrounded by plaster casts of Greek statues.

According to his own account, this was the first time he was really promiscuous. On the whole, David usually had affairs with one person, and they lasted for quite a while. Without being an innocent or a prude, he has a cautious live-and-let-live attitude about other people's sex life. 'We all are attracted by "naughty" boys,' he told me, and when I asked if he had sexual fantasies he laughingly replied, 'I sometimes think it would be nice to have been a hustler, but of course, as you say, this is fantasy. A lot of sex is fantasy, and the more you have it the more you want it. I can actually go a long time without it. If I have good sex with one person I'd rather do it again with him, rather than searching for new kicks.' Open-minded about other's promiscuity, he refuses to let sex dominate his life. The only thing that is allowed to do that is his work.

California comes nearest to his sexual dreams and in his self-portraits the

image of the shy and vulnerable young man of his earlier work was replaced by stances of open defiance and joy. Is Hockney the *Jungle Boy*, the picture of the man under a palm tree, walking towards a snake as if to kiss it, or the circus *Acrobat*, who rides with outstretched arms upright on a white horse, ready to jump through a ring on fire? These two etchings date from 1964. 'Maybe,' he always replies with a broad smile when asked a direct question about a particular work.

Things always work out for David and the new environment spurred him on to work: 'Los Angeles is almost the first place I have drawn. In London I was put off by the ghost of Sickert, it was haunting me too much so I could not see it properly. But here there were no ghosts, there were also no paintings of Los Angeles. And suddenly I thought, my god, this place needs its Piranesi, so here I am.'[19] The person who was cheerfully telling me this was driving through the city's Venice district by the sea in a large convertible with the radio playing Mozart. 'Venice' he announced, passing roller-skating boys, 'is a bit like Europe, it's like a sunny naked version of the Portobello Road, with more sexy people.' Were it not for his Bradford accent or some slightly nostalgic references to London, here was the image of someone who seemed to have never known another life.

Almost as soon as he had arrived in L.A. he made new friends, among them the future film producer of *Urban Cowboy* and *China Syndrome,* Jim Bridges and his lover Jack Larson, writer and librettist for the composer Virgil Thomson. Through an introduction from Stephen Spender, he also met Christopher Isherwood, and his lover, the strikingly handsome painter, Don Bachardy. With both he forged a long-lasting and deep friendship. Christopher was a small neat man with eyes the colour of periwinkle which seemed to scrutinize everything around him. He usually wore a natty corduroy jacket and his hair was very cropped; at the age of seventy, this gave him the boyish look he wanted. Like David, he had come from England and fallen in love with California and the boys. When Christopher was forty-

eight years old he had met the nineteen-year-old Don. They remained together for the rest of his life. Don, from an early age, had a fetching shock of silver hair and deep, beautiful eyes which, despite a broad smile, exuded a certain sadness. He also had an alertness to the possibilities of life which was very captivating. When David met the two, Christopher was already famous but Don had also begun to make a name for himself by drawing Hollywood people.

In Los Angeles David rented a small studio and returned to one of his favourite subjects, the nude male. He was now using acrylic paint rather than oil. In *Two Men in a Shower,* one figure is just hidden behind a colourful curtain, thus increasing the sexual teasing. In the London shower paintings we seem to know who the bathers are; now they are anonymous, identified simply as 'Man' or 'Boy', a reflection of the casualness of the occasion. Sometimes these paintings were taken directly from life, at others from magazines such as the *Athletic Model Guild.* The intimate picture of two men taking a shower together, one soaping the other's back in *Domestic Scene, Los Angeles* was inspired by a photograph in *Physic Pictorial.*

The bodies had become more sensual, with rounded jutting buttocks, a more athletic version of his London nudes. In his early drawings, the scenes between the boys were born out of his imagination, invented. The scenes of his boys now were far more naturalistic, observed. His growing interest in photography might also have prompted him towards more identifiable settings. Places became more specific, less imaginary. The shower scenes of 1964/65 – *Boys Taking a Shower; Boy about to Take a Shower,* or *Man taking a Shower in Beverly Hills* – grew more realistic. The carefully painted, almost shadowless bodies, are outlined against the tiles. The clear and clean pictures point to a new kind of painting, the Californian way. In the past, his paintings had been fragmentary, schematized, the work of a story-teller. The new works were those of a voyeur. 'All artists are voyeurs, they know about the delight of the eyes,' David said while looking at some reproductions of these

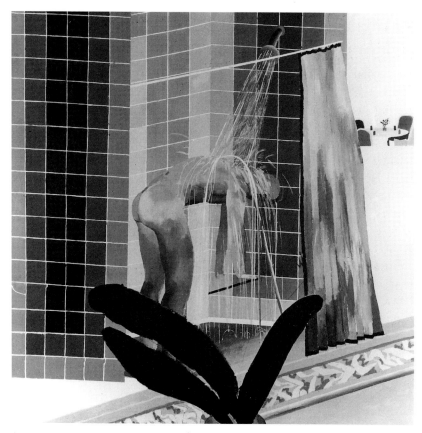

MAN IN SHOWER IN BEVERLY HILLS, 1964, ACRYLIC

The architecture of pools and motels and linear houses became metaphors for the new world he was living in.

paintings. His amused voyeurism transmits itself directly to the onlookers.

Hockney had finally shed all 'Englishness'. The modernist works now exuded a crystalline clarity of light and colour and a feeling of empty space. They were deadpan flat images that simply said, 'Look what I have seen.' The striving for clarity became a major concern. The word 'fussy', which frequently creeps into in his conversations, is one of the things he most abhors. Few artists had painted the flatness of the Los Angeles landscape, which came as a surprise to Hockney. The architecture of pools and motels and linear houses became metaphors for the new world he was living in. He painted a landscape as disconnected as it possibly could be from his past, a landscape of inanimate objects in which the only continuum was the presence of friends. The crisp images in the blazing colours of blue and yellow almost look like travel posters, advertising and inviting us to a carefree world of sunlit scenes. But Hockney's ironic sense of detached observation saves them from being just that. Many of the pictures were based on the photographs David was taking with increasing passion. Some of his pool paintings came from advertisements, but they were not straightforward transpositions of photo onto canvas. Far from being naturalistic renderings, the final picture was highly complex and contrived, and the result of the manipulation of many different sources.

In the summer of 1964 David got a teaching job in Iowa City, a place he didn't even know on the map. He bought himself a new pair of saucer-eyed, horn-rimmed glasses to replace his English National Health ones – 'I think I looked very distinguished' – and drove to Iowa City in his smart convertible Ford Falcon, staying in cheap motels and 'picking up hitchhikers' en route. He was by all account a very good teacher, although he always claimed that he was terrible as he never knew what to say when he didn't like a painting. Only teaching drawing, he claimed, gave him any pleasure. In any case, one can only imagine the impact this bleach-blond teacher with the peculiar accent had on his students, many not much younger than he.

He was given a studio in Iowa, so he painted quite a lot, finishing *Man Taking Shower in Beverly Hills*. Some of these paintings no doubt intrigued and amused his pupils. Works such as *Cubist Boy with Colourful Tree*, described by Hockney as 'an American athlete painted in a decorative cubist manner', showed a nude man with a jutting, sensuous behind, wearing only a T-shirt.

Ossie Clark came out to visit him in Iowa and the two drove back to Los Angeles together. By the end of 1964 his first visit to California came to an end, and he drove with Ossie once more across the United States to New York where he had his first American exhibition at the Charles Allen Gallery. He spent much time with his old and new friends, among them the English painter Mark Lancaster and Henry Geldzahler. Henry Geldzahler, an influential figure in the New York art world, was not only a formidable friend but also one of Hockney's major champions in America. He began as the curator of the American Painting Department at the Metropolitan Museum and soon rose to be responsible for the entire Department of Modern Art. As the Commissioner of Cultural Affairs of the City of New York, he fostered the work of many artists. 'I am Geldzahler, not Geldzaehler,' he once said to me, 'a money-payer not a money-counter.' He was responsible for important shows of Clyfford Still, David Smith, Elsworth Kelly and David Hockney, but his most famous exhibition was the blockbuster *New York Painting and Sculpture, 1940–1970*.

By December David was back in London. Richard Hamilton had invited him to give a talk at the Institute of Contemporary Arts. David chose to talk about homosexual imagery in America. To the delight of his audience, he projected images from gay magazines and even a short clip from a rather tame porno film with the title *Leave My Ball Alone*. David was in fine form, mixing mischievousness with thought-provoking content and the evening was a huge success. Hockney loves an audience. A natural and tireless raconteur, he performs well and completely without posture in front of the public or a camera, although he is well aware of his effect. He has fine-tuned the appearance of someone totally at ease with himself, achieving that rare

balance of someone who shares a familiarity with his audience while at the same time keeping his distance. He is a true performer.

His books and his frequent appearances on television bear that out as well as displaying his comprehensive knowledge of the history and practice of art. It is almost impossible to be bored by him. He is in fact the perfect interviewee, and one is struck by his capacity to analyse his own motives and work, although he always claims that an artist should not have to do that.

David established a pattern of going back and forth between London and California. The next time he returned to London he brought with him a new friend from California called Bobby, the pretty all-American boy, blond, very sexy and rather dim. They had met in a Los Angeles gay bar – 'it was lust, sheer lust'[20] – and David, in his often insanely generous way, had invited him to New York. Bobby was rather lost in the crowd and the boy from California hated everybody and everything, including New York. To cheer him up David brought Bobby with him to London where David had a show at Kasmin's Gallery. They travelled on the revamped *France*. Most people thought David was mad, but he was proud to show off his new friend. He took him everywhere, 'once to a club where Ringo sat at a nearby table. But not even that impressed Bobby, all he wanted was sex,' David smilingly remembers. Then something must have gone wrong because a week later he announced that Bobby was gone. All that remained of Robert Lee Earles III was a drawing entitled *France*. It showed a delicious bottom, but not Bobby's face. He became a go-go dancer. The whole story was rather typical of David, and when he tells me that Bobby died of an overdose, his sorrow is evident. This too is typical of David.

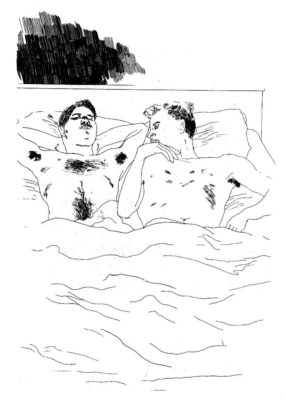

IN THE DULL VILLAGE
1966, ETCHING

They are images of nonchalance, of boys looking the viewer straight in the eye, unashamedly, almost insolently.

For the love of boys

Hockney freely admits to the inspiration he receives from the works of other artists. He frequently cites Picasso, van Gogh, Caspar David Friedrich and Matisse. His imagination is also stimulated by literary and musical sources. But what distinguished him from most of his contemporaries is that he often turns to sources in the past rather than in his own time. In the same way as Whitman's poems on the love of comrades had been very influential, so was the work of another homosexual poet, C.P. Cavafy, whose love poems he had read in his youth – as Cavafy's work was out of print he had nicked a copy from the Bradford library – and which he began to illustrate in 1966.

POET YOU ARE NO LIAR, THE WORLD THAT YOU IMAGINE, IS THE REAL ONE. THE MELODIES OF THE HARP ALONE KNOWS THE TRUTH, AND IN HIS LIFE THEY CAN BE OUR ONLY TRUE GUIDES.

These lines from Cavafy had a deep effect on the young painter. The Greek, Constantine P. Cavafy (1881–1933) spent most of his life in Alexandria. His output was small and only a few of his poems were published during his lifetime. Many writers, among them E.M. Forster and Lawrence Durrell, spoke in glowing terms about this great poet, and Christopher Isherwood used to cite him.

Hockney had already referred to Cavafy in early etchings: *Mirror, Mirror on the Wall* quotes a line from the poem 'The Mirror in the Hall', and *A Grand Procession of Dignitaries in the Semi-Egyptian Style* was inspired by Cavafy's great poem *Waiting for the Barbarians*. The *Kaisarion* and *All His Beauty*, done after Hockney's return from Egypt in 1961, had been based on Cavafy's

Alexandrian Kings. In the poem, Kaisarion, the son of Caesar and Cleopatra, is portrayed as a beautiful youth:

DRESSED IN PINK TINTED SILK,

ON HIS DRESS A GARLAND OF HYACINTHS,

HIS BELT A DOUBLE ROW OF SAPPHIRES AND AMETHYSTS;

HIS SHOES WERE TIED WITH WHITE RIBBONS,

EMBROIDERED WITH ROSE COLOURED PEARLS

Hockney's figure is far from beautiful, his title *Kasarion with all his Beauty* seems almost ironic. Could this be another of his self-doubting portraits as an artist longing for beauty?

Hockney had read Lawrence Durrell's *Alexandria Quartet* and was much struck by the description of Cavafy's home town. But after his first visit, as with Isherwood's Berlin, he was disappointed to have found neither Cavafy's nor Durrell's place. 'All the Europeans were gone.' So David went for two weeks to Beirut, walking through the streets in search of the 'seedy atmosphere' Cavafy had written about. The poet, living above a famous brothel in the rue Lepsius, described the sadness and the beauty of that love that grew in poverty and sordidness. His poems transmit a touching picture of the secret and sometimes sordid life in Alexandria at the turn of the century. They talk about a glimpse of an eye caught in a crowd, the face of a boy being picked up, men cruising and waiting, of poignant, furtive and brief encounters.

HE GOES REGULARLY TO THE TAVERN

WHERE THEY MET THE PREVIOUS MONTH.

HE MADE INQUIRIES, BUT THEY WEREN'T ABLE TO TELL HIM ANYTHING.

FROM WHAT THEY SAID, HE GATHERED THE PERSON HE'D MET

WAS SOMEONE COMPLETELY UNKNOWN.

BUT HE STILL GOES TO THE TAVERN REGULARLY, AT NIGHT,

AND SITS THERE GAZING TOWARD THE DOORWAY,

MAYBE HE'LL WALK IN. TONIGHT MAYBE HE'LL TURN UP.

HE DOES THAT FOR NEARLY THREE WEEKS

HIS MIND IS SICK WITH LONGING.

THE KISSES ARE THERE ON HIS MOUTH.

HIS FLESH, ALL OF IT, SUFFERS FROM ENDLESS DESIRE,

THE FEEL OF THAT OTHER BODY IS ON HIS,

HE WANTS TO BE JOINED WITH IT AGAIN.

OF COURSE HE TRIES NOT TO GIVE HIMSELF AWAY,

BUT SOMETIMES HE ALMOST DOESN'T CARE.

BESIDES, HE KNOWS WHAT HE'S EXPOSING HIMSELF TO,

HE'S COME TO ACCEPT IT: QUITE POSSIBLY THIS LIFE OF HIS

WILL LAND HIM IN A DEVASTATING SCANDAL.

Hockney, too, knew much about the charm and the pain of the fleeting encounter, about the desire to belong and to remain apart. Cavafy's poems are about poetry and art; much of Hockney's work is about art and poetry. In the last poem chosen by Hockney for the series of etchings, a man looks at a beautiful boy. 'From Art's toil we rest again in art', a line which could easily represent Hockney's life. Through the work of the artist a young man can rise above his poor existence and become a god.

AS HE WAS WHEN HE TOOK OFF THOSE UNWORTHY CLOTHES,

THAT MENDED UNDERWEAR, THREW IT ALL ASIDE,

AND STOOD STARK NAKED, IMPECCABLE HANDSOME, A MIRACLE —

HIS HAIR UNCOMBED, SWEPT BACK,

HIS LIMBS A LITTLE TANNED

FROM HIS MORNING NAKEDNESS AT THE BATHS AND ON THE BEACH.[21]

Two of Hockney's friends, the poet Stephen Spender and the Greek Nikos Stangos, collaborated on a new translation of Cavafy's poems for Hockney to illustrate. Working with a new printer, Maurice Payne, who became a friend

and his assistant, Hockney did twenty etchings, of which only thirteen, with their poems, were published. Cavafy's nostalgic and poetic vision of the love of man, eloquent in their expressions of pain and longing, inspired Hockney to some of his most poetic renderings. They also rank among his best line drawings. Hockney always liked etching, finding it superior to the more mechanical screen-printing, so much in vogue during the sixties. He often spoke about his joy in working in this form of graphic printing, an involvement he sometimes missed in painting.

His Cavafy etchings are not direct illustrations of the poems, but rather an evocation of the mood they express. Cavafy's homo-erotic works talked mostly of boys he fantasized about, conjured up from his dreams, whereas Hockney's illustrations are taken from life and some of the Alexandrian street boys were modelled on his London friends. Other inspirations came from physique magazines or snapshots he had taken in Beirut.

Hockney's are a more straightforward rendering of the love of man in less restricting times. With the thrill of the forbidden and the guilt that ensued, they are images of nonchalance, of boys looking the viewer straight in the eye, unashamedly, almost insolently. Of the thirteen etchings, only five show naked lovers in bed. There are no genitals visible: 'the hidden tone of the poems dictated a kind of bashfulness'. Only one picture, *In an Old Book*, shows a totally nude boy who looks defiantly at us, his hands folded behind his head proudly displaying his sex. The title refers to the contents of Cavafy's poem which describes how he had discovered the image of a beautiful boy of utter sensual love in an old book. His images repeatedly show two boys – in a living room, on the street, or in bed. They are ready to make love or have just fallen asleep, exhausted from it. As in so many of Hockney's double portraits, what is striking is that despite the boys sharing the same bed, they do not seem really together, the intimacy of an embrace is lacking. Some are staring into space, as though into nothingness.

In 1967, in a limited edition, the Cavafy poems with Hockney's illustrations

were published by the Petersburg Press, which then operated from a small print shop in a Kensington mews. Ironically, although by many critics considered to be among his best works, because of its openly homo-erotic subject, these prints sold less well than others of his, and the entire book could be bought for a mere £75. The illustrations to the *Rake's Progress* and the *Grimm Fairy Tales* fetched higher prices.

Hockney's nudes are often more suggestive than explicit. Although there are quite a number of frontal nudes, the majority of his boys are half-dressed. David is not interested in public exhibitionism; he prefers a private innocence: 'I draw nudes when I live with people.' He also likes to draw his lovers and friends when sleeping, as in *Mark, St Francis Hotel, 1971, Mark, Mandarin Hotel, 1971* and *Mo Asleep, 1971*, a naked man outstretched on a deckchair. There is Peter asleep in *La Plaza Hotel, 1972, Gregory Asleep, Sunday Inn in Houston, 1976, Gregory in Bed in Hollywood, 1962, Randy Sleeping* and a *Nude Boy* from 1978. 'I am always the first one up, so somehow this is an account of me seeing them.'

Hockney has always been an early riser, he likes the morning, that state in between dreams and consciousness 'when the mind is still free and uncluttered. I sometimes have my best thoughts in the morning in that sort of sleep-walking state with the whole house around me still fast asleep.'

The lifelong habit of indicating the date and place of his works emphasizes the diary-like character of his work. The fact that the sleeper is naked, obviously sharing a room with the artist, conveys the intimacy between them. But on the whole, the pictures of Hockney's men are more portraits than actual nudes, despite the state of undress of so many of his sitters. David's relationship to pornography is straightforward. He enjoys looking at it, and uses it as a source for his work. He will defend the right to produce it or to enjoy it freely. He himself has done almost no drawing which could be classified as 'pornographic' – a term difficult to define. But some of his work

is undoubtedly enjoyably erotic: *An Erotic Etching* from 1975 shows a guy
with a very large erect cock giving another guy a blowjob. Done for Peter
Webb's book, *The Erotic Arts*, David included a little bouquet of flowers on
the wall. Peter Webb, in his biography of Hockney, tells us that David had
'made a large and marvellous line etching of two boys making love. It was
too large for the book, so David agreed to make a smaller version of it.' The
print achieved notoriety as some British museums refused to include it in a
drawing show that travelled throughout the country.[22] There is also a
drawing from 1972 called *Human Clay* of a boy playing with his cock.
Hockney is no moralist. He gives everybody his own territory of desire for
life must be lived within one's own skin. 'There is nothing wrong with
pornographic work, like Tom of Finland, he was a very good craftsman and
artist, only when the work becomes just a formula does it become boring.'

AN EROTIC ETCHING, 1975, ETCHING IN BLACK

Living the Californian dream

In June 1966 David went back to California and renewed his passion for pools. The presentation of water as a surface was, of course, an artistic challenge, but pools, like showers, were also an occasion for nudity. The artist's unabashed pleasure in showing nude boys communicates itself directly to the viewer. The nakedness of the models and the warmth of human flesh are in stark contrast to the almost sterile surroundings. The figure or figures in all of Hockney's works are the determining features, not the surroundings, even though, as in *Sunbather* only a third of the canvas is occupied by the naked bather, lying face down on a towel, while two-thirds is taken up by the water.

David likes bums. In most of his shower and pool paintings, the bathers are seen from the back. The increasing use of colour pencil sometimes highlights the fleshiness of the bum as the central and most sensual feature. There are boys lifting themselves out of the water, like the two in *A Pool in Hollywood*, and revealing their bare backsides. Others are sprawled on hot tiled surfaces. *The Room in Tarzana, Sunbather* and *'Bob' France* all show boys asleep, face-down, presenting their rear-ends like an invitation to fuck. In a painting aptly called *California,* two boys float on a rubber mattress, their naked bodies with marked tan-lines turned towards the sky. Pools and water became central to Hockney's work, culminating in the three versions of one of his most famous paintings, *The Bigger Splash.*

As always, the work charted the events of his life. The Peter in *Peter Getting Out of Nick's Pool* was his new lover, Peter Schlesinger, and Nick was his agent, the well-known art dealer, Nicholas Wilder, who had a gallery on La Cienega Boulevard. David stayed with him in West Hollywood during this

PETER, 1969, ETCHING

time. In another painting, we see the strikingly handsome Wilder in the middle of a pool in front of the linear architecture of a Los Angeles motel.

Peter Schlesinger was only nineteen and an art student at UCLA where David sometimes taught. 'I had gone there to teach a painting course, hoping to see a lot of bronzed surfers behind their easels. All I found were a lot of

Californian housewives, and suddenly this gorgeous boy walked in,' recalled David. It was Peter, a personable and handsome slim young lad with long, blond hair. He was shy and had a sweet smile, the very image of what David liked. He fell hopelessly in love, but as Peter came from a very strict Jewish middle-class background, it took him time to be able to reciprocate David's ardent feelings. But by the end of the summer it was clear to all their friends that the two were having a great romance.

For the next years, Peter was David's favourite model. The titles of Hockney's works trace the ports of call in his travels with Peter: *Peter having a Bath in Chartres* or lying in a bed in *Dream Inn, Santa Cruz,* Peter in *La Plaza Hotel, Peter, Hotel Regina Venice, Peter in the Mamounia Hotel* in Marrakesh, or in the *Albergo la Flora in Rome*, a sensuous nude on the bed, gazing at the ceiling. In the same room David drew his new lover as a handsome young man leaning against the shutter of the window wearing only a small gold chain.

The early drawings of his new lover were almost coy, often showing only the upper part of the body, as if the painter refused to share his lover's nudity with the world. Some were almost like a tease. In two drawings done of Peter in San Francisco, we see him first in his underpants and then under the shower. Only from 1967 onwards are we allowed to see Peter totally naked. In 1968 and 1969 the frontal nudes of his lover multiplied and took on more and more sensuous forms. Some of the drawings are tender and delicate; others display a sense of urgency – renderings of both tranquillity and passion.

The portraits display a great intimacy, conveying a feeling of complicity and physical ease between painter and model, as in the sleeping – thus secretly observed – Peter, wearing only a T-shirt and white socks in *The Room in Tarzana*. Hockney had based this painting on a photo of a bed in Macey's mail-order catalogue. He liked the bed for its sculptural qualities and simply copied it, and added his semi-nude lover. Marco Livingstone, in his enlightening assessment of Hockney as an artist, points out that this painting

was influenced by François Boucher's *Reclining Girl*, a saucy reference which David will now neither deny nor confirm. In any case, the erotically charged image of white socks was for him another metaphor of California.[23]

From 1966 to 1967 Peter and David lived in a small, run-down house on Pico Boulevard, 'a seedy little place, a converted garage. It didn't even have a telephone. Whenever I had to make a call I went to the telephone box just outside. It was quite funny; sometimes I had to talk to dealers arranging the sale of pictures worth a couple of thousand grand.' Peter was really the first person David had ever lived with on a permanent basis. There had been short affairs and he had travelled with lovers, but now he was living with a lover on a day-to-day basis, and he liked it a lot.

Until then David had always been a roamer; he had to go out to see and to meet people. 'It was my last gypsy period,' he confessed. He stopped cruising; there was no need any longer and, in any case, Peter was far too young to be admitted to bars. So the two went out only to eat in little restaurants or to the movies. The advantage of this quiet domestic life was apparent to all. Not only had David lost much of his restlessness, but he also got a lot of painting done. As there was so little space at home, he rented a room in a house nearby. This too was very small, but Hockney managed to do some very large paintings there, although he had hardly enough space to step back and view them. The paintings, done in flat acrylic, were neater and larger in scale than earlier work. The earlier scribbles and rough surfaces made way for a cool elegance, a feeling of crystal-clear emptiness, even stillness.

Not that life was totally quiet. Friends visited from London and Nick Wilders house 'was always filled with pretty boys'. Peter and David also travelled; they had bought an old Volkswagen and drove across the United States. But David always loved to return to England to see friends and the family he is so deeply attached to. And Kasmin had offered him another show; the price of his paintings had risen to $1000.

Homeward bound

In 1967, after his intense five-year love affair with America and everything American, David longed again for Europe. Bored by the predictability of Los Angeles, he was restless for new sensations and so in June he and Peter travelled to Europe on the *Queen Elizabeth*. It was Peter's first visit. Everybody was charmed by Peter's gentleness and his success gave David great pleasure. 'To tell the truth I had only come to London because Peter wanted it. At that time, I would have moved anywhere with him,' David recalls. The two lovers settled into Powis Terrace, but Peter also had a small studio around the corner. Thanks to Peter, David's place was transformed. It had never been tidy at the best of times — David was not what one could call house-proud — whereas Peter brought back treasures from the nearby Portobello market filling up the flat with pretty Mackintosh chairs and Art Nouveau vases and *objets*. David looked on with pleasure and amazement when a leather sofa was delivered from Harrods costing £400, quelling his slight sense of rebellion after his frugal upbringing. But what David loved most was seeing his old friends and his mother and father. He had never cut his roots despite the diversions of his life. It was in his parent's house that he had learned first who he was, and much of his universe was created there. David had bought a new Morris Minor convertible — what he called his 'District Nurse Car' — and I remember driving to Keith Vaughan's new country house in Harrow Hill in Essex. We swam in a little natural pool Keith had dug out of the land and David killed himself laughing as he fought off the newts. Nothing could have been more different from California. The two painters talked about how akin painting is to the act of making love, and how much their love of men 'coloured' their work. Keith felt no guilt about his homosexuality — indeed, his work was an affirmation of it — but, unlike

David, he belonged to the generation brought up with the idea that it had to
be kept a secret. In a note in his published diaries he wrote 'The whole thing
seems to be in bad taste when it is flaunted in the face of the public.'

And yet he admired the openness of the new generation, especially in sexual
matters. In another entry he noted:

> *The more I see of D.H. the more he impresses me. He has all the best qualities of*
> *his generation. Modest and self-confident, honest in speech, unconcerned with*
> *impressing, yet considerate and well-mannered, impatient with all fraudulent or*
> *compromising behaviour, ardent, curious, warm-hearted, uncorrupted (and probably*
> *incorruptible) by success – his generation have never known dire poverty I suppose. I*
> *feel so much better after such an evening.*[24]

In London there were endless dinner parties, David always being a much-
coveted guest. He is a great story-teller and a delicious gossip without real
malice. Holding the centre of the conversation and wanting everybody to
share his festive state, he freely dispenses his original, innovatory thoughts and
then suddenly throws in a sort of fortune-cookie truism, reducing everybody
to laughter. David was much fêted and for his birthday on 9th July that year,
Lindy and Sheridan Dufferin threw a brilliant party in their house in
Kensington which included most of his friends and such luminaries as Princess
Margaret, her husband Tony Snowdon and the veteran Bloomsbury painter
Duncan Grant. As always, David enjoyed the limelight, but without ever
being unduly impressed by his new stardom. What has always astonished those
who are closest to him is how he is able to balance the demands of a rich,
private inner life with those of a high public profile. He relishes being in
company, yet he is also a loner. Anybody who has ever attended a public
function with him notices immediately how intimidated he is by vast crowds.
The amiable charmer, the dancing clown, is only one side of this complex
man.

Christopher Isherwood and Don were also in London, on their yearly visit to

E.M. Forster, always referred to as Morgan. They had rented a small cottage next to Hampstead Heath that had once belonged to Richard Burton, and Christopher entertained many of David's friends- Patrick Procktor, Ossie Clarke and Mo among them.

There were many other diversions. David went with Christopher and Don to stay with Benjamin Britten and his lover Peter Pears in Aldeburgh, and they visited Dodie Smith, the author of the hit play *Dear Octopus* and of *The Hundred and One Dalmatians*. She lived, as David cheerfully remembered, 'with her 101 Dalmatians' in a thatched cottage, which he described as 'a teapot with doves flying in and out'. When Walt Disney had visited her he could not believe that it was not he himself who had designed her house. This story always reduced David to hysterical laughter and he would tell it over and over again.

Having shown Peter the sights – and the people – of England, the two lovers went on a tour of Europe. David always liked travelling in groups. He invited Patrick Procktor to come along and the three drove off in the little Morris Minor, Peter and David occupying the front seats while the well over six-foot Patrick was cramped up in the back. They stayed with the American art critic Mario Amaya in his farmhouse near Lucca. The vivacious, highly amusing and sometimes quite outrageous Mario had been a friend for many years. In his book, *Pop as Art*, he designated Hockney as one of the most influential figures in England in this period.

After Italy they went to France to Carennac in the Dordogne where Kasmin, his wife, Jane Nicholson, the niece of the painter Ben Nicholson, and Howard Hodgkin had rented a château. Carennac became for years one of David's favourite holiday places. There they found many more old friends from London, among them David's publisher, Peter Cornwall-Jones. Hockney captured these happy days spent with his friends in many drawings in which Peter, of course, figured prominently. The innocent-looking American kid had grown into a smart, sophisticated young man. That year Peter and David

spent Christmas in Paris, joined by Patrick Procktor and Ossie Clark. They met up with yet more friends, among them the designer Jean Léger, his lover Alexis Vidal, an antique bookseller, and the novelist Yves Navarre.

Hockney's journeys with or to friends involved a lot of parties, but they also provided possibilities to sketch and to collect subjects for future paintings. He almost always draws and it is rare to catch him without a sketchbook, recording his sensations, sometimes in rapid jottings, sometimes in more elaborate and finished lines. He often pointed out that two 'giant' painters of the twentieth century, Picasso and Matisse, never ceased to draw the human figure. 'All artists should draw. Teaching drawing is the teaching of looking,' but he also concedes that 'the craft can be taught, not the poetry.'

He likes to draw the same people over and over again. 'As I do not like to use professional models, friends are the obvious choice. To draw someone is also an act of complicity, even intimacy, and sometimes instead of having a conversation with a friend, I'd rather draw them; this is also a kind of conversation I have with them.' Hockney is not always concerned with likeness. 'I do not always want to struggle for likeness; of course you want to look into somebody and find things about their personality and character, but I do not always want to struggle for likeness. Drawing is the most personal, intimate medium. A drawing is about two people, the person who draws it and the person who is sitting. The likeness just seems to happen sometimes.'[25] He dislikes drawing from a photograph, a practice now common among artists. 'A photograph from a face does not give me enough information, only the real person can give you that.' The frequency and speed with which he draws his friends has given him the reputation of doing things easily. But he refutes such a claim: 'For every drawing that looks easy there are probably eight in a drawer that have gone wrong.' He acknowledges that in the hierarchy of drawing skills the human form is the most difficult: 'Faces are the most difficult, hands are next and feet.' Line drawing is particularly difficult 'because you are not just doing an outline, you are drawing different things,

textures, surfaces, and while you try to reduce everything to a line, a tenseness builds up inside you, while you are looking and drawing, your mind is totally taken up by it.'[26]

I sat for two portraits, or more precisely, I sat for one, in the sense that I was asked to pose, and the other drawing happened by chance. We had travelled to Amsterdam and were having breakfast, both reading the morning papers. But suddenly I looked up and noticed that David had been drawing me. It could not have taken more than a few minutes. 'I notice that if I draw quicker it is more accurate about your feeling, for what you are doing; and you can acheive something more economical'.[27] He signed it: 'Peter reading the *Herald Tribune,* Hotel Ambassade, Amsterdam'. For the second portrait, I posed on the terrace of his house in Los Angeles while we were waiting for my cameraman to reload the film. An immaculate sheet of white paper lay on the table. David looked at me for a short while, squinting slightly behind his glasses, scrutinizing his subject. There was total silence, then he began to draw in fluent movements. When he draws he is very concentrated, very tense, his eyes always shifting in rapid movements from the page to model and back to the page. Sometimes when he paints he has some music playing, but when he draws he needs absolute quiet; he never talks, his mind is completely taken up by the activity. From time to time he pauses, surveying once more the sitter and his image on the page. He never seems to rub anything out, rather he starts anew. At the end, he broke the silence, he seemed to be happy with the result, but he did not say so. He got up and put the drawing away in a drawer. This second picture took much longer. These two ways of doing portraits are typical of Hockney's way of drawing. On the day I left Los Angeles he signed and handed over the drawing, saying, 'You should have this.'

Another way David captured impressions of his travels was by taking Polaroid photographs. The increase in his passion for photography can be measured by his albums: the first covers six years, from 1961 to 1967, while later ones each cover only a few months. During 1970 he filled no less than eight albums

with travel photographs. They bear witness to his often romantic attachment to places and to friends, most of whom have ended up in one of the green albums, numbering over one hundred. 'I am just a snapper, all of life, it's a sort of pictorial record of my life, and most people who enter it end up in one of the albums, and later maybe I draw them. There are lots and lots of pages of painting and drawings in progress slumbering in these albums. It's just like a diary.' But he has doubts about the artistic validity of the medium. For Hockney a photograph of the Mont Saint Victoire is less real than any of the paintings Cézanne did of his favourite landscape. 'I think it's just a small medium. Painting comes much closer to the real experience of watching what happens in life. Painting is more real than photography. It's got time in it, layers of time. The photograph is the frozen moment. I think a picture says so much more about a person, but the Home Office wouldn't let me put a portrait in my passport, they say: "This isn't real".'[28]

If many of his Polaroid pictures were more like *aides-mémoire,* with the purchase of a Pentax, photography became a more serious pursuit of its own. Hockney shared this passion for photography with another painter, Andy Warhol. The two had met in New York and became friends, eventually making portraits of each other. In 1971 Warhol had come to London for his first big exhibition at the Tate Gallery. He had arrived with a whole group of friends, among them Jane Forth and Joe Dalessandro, and they all stayed at the Ritz Hotel. Because of the heat, they mostly lounged around in the room, stark naked, except for Andy, who was wearing a big sweater. He was, as usual, encouraging everybody else who came to see them to take their clothes off.

One afternoon we all descended on David, who was much taken by the handsome physicality of Joe, and immediately started to click away with his camera, while Andy frantically went through the photo albums. It was a strange sight, the gaunt figure of Warhol and the jolly one of Hockney. Warhol laughed a lot, his white plasticized face suddenly cracking open like a plaster cast. This was quite disconcerting as usually he shrouded himself in a

sort of mysterious silence, his blank eyes revealing nothing, rarely laughing.

I remember thinking how different the two painters were despite their superficial similarities. Both came from working-class backgrounds, both had known spectacular success. They enjoyed their public images as eccentrics. Both flaunted their homosexuality with abandon. But they were like different faces of the same coin. Warhol craved fame and affection, and when he found them, he looked at them with ice-cold detachment. Hockney also enjoyed fame, but he savoured it with childlike joy. Warhol's maxim, 'I starfuck, therefore I am', was not for David. Both were the centre of a large group of hangers-on, but Warhol governed his with a demonic grip, leading them on in a kind of dance of death whereas Hockney was the benign centre of cheerful youngsters and friends.[29] Hockney's tender and fine drawing of Warhol in 1974 shows him in a formal suit and tie, sitting in a chair and looking slightly forlornly into space, thus avoiding our gaze. Warhol's colourful screen-print shows David looking straight at the viewer while languorously putting a finger in his mouth. Both artist had caught their counterpart admirably well.

David and Andy remained friends although they did not see each other very often. In 1986 Hockney contributed a two-page spread of colour reproductions to Warhol's famous magazine *Interview*, and when Warhol died, David went to New York to join the large and incongruous crowd for his memorial service.

In 1968 Peter Schlesinger was accepted as a student at the Slade. But by then David had a strong hankering to go back to Los Angeles. He kept on grumbling about England, its class-ridden society, its narrow-mindedness, its puritanism and most of all its 'uncivilized' pub hours. 'Just when you met someone nice they called out "drink up, closing time!" People don't need so much sleep,' he announced, and Christopher Isherwood added, 'God must have been very tired when he created England.' David always railed against this theme park for tourists with its changing of the guards and nobility with country houses and the corridors of power clogged with public-school boys

and drugged aristocrats, in short, English conservatism. 'The pettiness of England with the mean-spirited self-appointed officials, who tell you how to live. They are only there because they belong to the right class. Little people with no creativity or imagination. Instead of opening England up, it closes it down... 'You are lucky you're a foreigner,' he often told me. 'Mind you, if you are a working-class lad from Bradford, that's just like being a foreigner.' David would never deny or forget his working-class roots; on the contrary, he is very proud of them. And although he is probably the best-known modern painter internationally, he has never been offered a title. Who knows if he would accept one, but "Sir David" would certainly be a source of much hilarity to him. 'Maybe they know that,' he points out.

Much of his anger at little England was fired by an incident which shocked and amused us all. David had come back from the States and had carried openly a number of pictures of nude men he had bought in 42nd Street in New York. Arriving in Heathrow, he was caught by British Customs, who confiscated the pictures as obscene goods. A fierce argument ensued between the artist, who needed them for his work, and the English official. David kicked up a splendid fuss. He mobilized half of London for his defence. The distinguished art historian Sir Kenneth Clark, who had written a book on *The Nude*, was willing to testify on his behalf in court. He contacted the head of the National Council for Civil Liberties. All the papers talked about it, and his mother phoned him to say, 'Isn't it awful when you need them for your work.' To be honest, the pictures were quite obscene, but that was not the point and David was actually quite amused by the whole thing. It was his mischievous side which made him kick up all that fuss. I believe the defence of civil liberty came second. The court case, David had hoped, would involve even the Home Secretary. And then one morning a man with OHMS on his cap rang the bell in Powis Terrace and handed him a big envelope marked 'On Her Majesty's Service'. He had to sign for it and when he opened it there were the Golden Boys and the naked hunks from 42nd Street. David has never forgotten this episode and his anger about what he calls the British 'prudishness' never subsides.

A chronicler of friendship

Few artists have recorded their friendships more consistently than David Hockney. As he says, 'It is I who decides who to paint,' and from 1967 to 1971 he did many portraits of his friends, some formal, others more casual. Among the more formal were a number of gay writers, including Angus Wilson, Stephen Spender and W.H. Auden. Hockney and Auden had never met, but a mutual friend, the music critic, Peter Heyworth, had arranged a sitting. David, who often travelled with a small group of people, took Kasmin and Peter along to meet Auden, thinking, in his usual generous way, that the poet would be pleased to see a pretty boy. Auden was furious; I was filming him at that time and he kept on about 'the manners of people who have no manners and the invasion of his privacy'. He could be difficult at the best of times.

He and his lover, Chester Kallman, spent most of their time on the island of Ischia, where the poet presided over a formidable array of guests, among them Christopher Isherwood, Stephen Spender and Truman Capote. His sunburned face was cracked into a well-ploughed field and he usually wore a white linen suit which had become the colour of bird droppings. At lunch or dinner Auden did the talking; one could not interrupt or argue for he held his audience silent with his not–to–be interrupted expression.

A more happy occasion for David was painting his old friend Patrick Procktor. David often referred to Patrick's studio as having once belonged to Auntie Mame, as he changed its look so often. David took many photographs and sketches of it, but the actual portrait was painted in the far more untidy Hockney studio. He placed his friend in front of the window to achieve a *contre-jour* effect, a device he much liked; he used it in the portrait of Celia

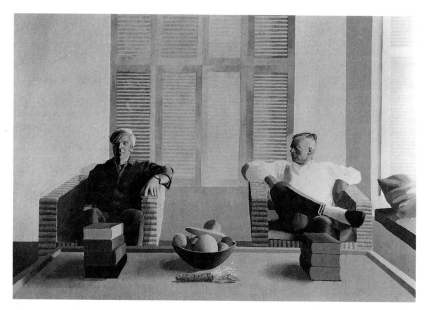

CHRISTOPHER ISHERWOOD AND DON BACHARDY
1968, ACRYLIC

Birtwell and Ossie Clark and in some of his Paris paintings. Patrick has the
look of a bird of prey. Theatrical in bearing and flamboyant in dress, he uses
his large hands for very extravagant gestures. Consciously 'camp' with a
refreshing sense of humour, he is what one would call 'very gay' in a Noel
Coward or Oscar Wilde way. David caught marvellously the colourful
personality of his old friend, although Patrick always complained that the
portrait was not very flattering, but then very few of Hockney's are. It is a
mocking but loving portrait.

Hockney's preoccupation with the relationship between lovers is evident in
the large number of double portraits he did in the late sixties and early
seventies. He painted his friends linked by love, friendship or marriage, and

most of the portraits were seven feet by ten as though destined to be hung over a mantelpiece. Their relationships are on display, to be looked at by all. One of the first of these was of Christopher Isherwood and Don Bachardy, painted in 1968. Hockney took many photographs and did some preliminary drawings, not only of the sitters but of their environment. Some of the objects from their house appear in the painting to suggest their domesticity. But Hockney was not concerned with verisimilitude. Henry Geldzahler has said that the window in his double portrait was actually in another room, and that the sofa was in dire need of repair, but David give it a chic new satin cover.

The Isherwood-Bachardy painting shows a new compositional concern. Gone are the flat surfaces, and the almost exaggerated perspective reveals Hockney's new interest in spatial complexities. He allows the viewer to *enter* a world rather than simply looking at it. In the acrylic painting – Hockney also did a watercolour – Don looks straight at us, while Christopher looks lovingly and slightly worriedly at his lover. This was not simply a formal device, but reflected accurately the relationship of the two which had lasted several decades. Christopher was quite possessive and was always worried about his younger lover, although he tried not to show it. Most of their friends were familiar with scenes during which Christopher, often flirtatiously, played the role of the older lover. He saw himself as the one who would eventually be forgotten. As it turned out, Don stood lovingly by him until his death. At dinners, which David gave often for his two friends, the conversation frequently circled around the difficulties of long relationships between men and as David was also involved with a much younger lover, he listened very attentively. Christopher called for sexual freedom among partners. 'I have the greatest respect for lust,' he once said. David protested rather feebly. Christopher refused the notion that gay couples had to imitate heterosexual ones – although he actually never used the word 'gay', using instead the old-fashion 'queers' or even 'buggers', which always made David laugh.[30]

In most of the double portraits of his friends, Hockney used the formal device of separating the lovers, like two creatures living in the same space but set apart — the impossibility of two becoming one, an image of two solitudes protecting each other as a sign of ultimate love. In the double portrait of Henry Geldzahler and his young lover Christopher Scott, Henry looks outward while Christopher looks at him, scrutinizing his thoughts. Except for David's lovers, nobody has been drawn or painted more often by Hockney than Henry. He had a great rumbustious wit with a rapier tongue. David and Henry shared a love of theatre and above all of music and opera, but what endeared him more then anything else to David was that here too was a man steeped in tradition, yet open to experiments and new ventures. He was formidably well-informed about the arts on both sides of the Atlantic. Like Kitaj, Geldzahler's origins were European: his family had moved to America from Antwerp when he was six years old. It is no coincidence that the two men with whom Hockney shared most of his artistic discourse, Ron Kitaj and Henry Geldzahler, combined the European and the American.

The double portrait of two other friends, the dancer Wayne Sleep and his lover, the bookseller, George Lawson, was painted over a period of three years between 1972 and 1975 and saw several revisions. 'Relationships often change so the picture did not reflect the reality any longer, so I often stopped or changed it.' George and Wayne are like two sides of the same coin, the dancer outward-going and a vivacious showman, while George was quiet, almost withdrawn. Hockney caught exactly their complex relationship: handsome Wayne stands in a doorway, clad in tight white trousers and light blue T-shirt, his lover George is seated, wearing a dark formal suit and bow tie. On the canvas they share the same room, but they seem hardly aware of each other.

In a sketch for another double portrait of Nick Wilder and his lover Gregory Evans from 1975, the two look in opposite directions. The painting was never realized, for the simple reason that Gregory had left Nick for David.

In all these portraits Hockney displays his extraordinary story-telling ability, a quality which is at the base of his great public success. The paintings are short stories about the often complex and complicated love life of Hockney's friends. Under the slick veneer and the simple composition lie tensions, unsaid words and the potential for emotional eruptions. Nowhere is this more obvious than in Hockney's best-known double portrait of Celia Birtwell and Ossie Clark, in *Mr and Mrs Clark and Percy*. Both had become famous in the world of fashion design. In 1969 when they married, David was their best man. Ossie and David had been friends for a long time and Celia would become one of his most enduring ones, as well as one of his favourite models. In the painting Hockney had painted on the wall one of his prints from *A Rake's Progress*, titled *Meeting the Good People*. As usual, David took many photographs and did many sketches before embarking on the actual painting. Like his other double portraits, Hockney set the scene in the house of the sitters, although the picture was actually painted in his own home. The picture was meant to be the portrait of a marriage. The pose, the lost gaze, even the facetious way the title hints at their alliance, signs of the impossibility of a relationship and of an unconventional marriage soon to break up.

Hockney reports that someone had once told him that 'his double portraits are like Annunciations; there is always somebody who looks permanent and somebody who's kind of visiting.'[31] The exception to these portrayals are portraits of two couples; one of them, *Michael and Ann*, depicts a contented couple, a homage to the Uptons. The painter Mike Upton had studied with David at the Royal College of Art and Ann, with her blazing red hair, had been a favourite model. Both Mike and Ann became close friends of David's and have remained so. The other is of Henry Geldzahler and his friend Raymond Foye. In the picture the two men clearly relate to each other. Significantly, it is called *The Conversation*. Those two paintings are also different from Hockney's portraits: he dispenses with background entirely, as if to say that the harmony of these two couples speaks for itself.

Strangely enough there are very few double portraits of Hockney with any of his lovers. In a pencil drawing, Peter Schlesinger is seated on a sofa with David walking towards him; in another, he portrays himself with Gregory Evans asleep on a sofa.

In 1970 Hockney had a large retrospective in the Whitechapel Gallery: shown were forty-five of his most famous paintings, including *Doll Boy, A Bigger Splash* and *Christopher and Don* plus forty-seven drawings and his entire graphic work. The public demand for his work was tremendous. He was quite shocked when he saw his paintings – ten years of his work – 'hanging all together'. Many friends remember how disappointed he was. He kept on repeating 'how protean art is'. It felt like an end of era. He was thirty-two years old. For many months to come he would not paint at all.

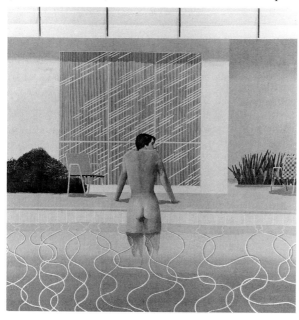

PETER GETTING
OUT OF NICK'S POOL
1966
ACRYLIC ON
CANVAS

Disorder and suffering

Living in London, David's relationship with Peter became difficult. The trouble had begun quite early in their London life as Peter had to go back to Los Angeles often – he was still a student at UCLA – and so David spent much time alone, or at least without him, because at that time David was hardly ever alone. Peter took his studies very seriously, but David, who was used to people being at his disposal, resented his absence. They had been together for four years and Peter, it became obvious to their friends, needed more independence as a person and as an artist. He had his own studio and the flat in Powis Terrace was enlarged to make room for the increasing demands on their personal and social life. The two lovers still travelled a lot, and the picture of Peter in Morocco on the hotel balcony is still full of romantic feelings. Paris was a favourite destination, but even there trouble loomed as David had met a very sexy American model, Joe Macdonald. The cracks were beginning to show. 'The relationship got a bit boring sexually for both of us,' David admitted, and he wanted to go back to California for 'some adventures.'32 So he took off and stopped over in New York where he met the photographer Robert Mapplethorpe. Robert, now renowned as the maker of highly erotic photographs, also had a quiet side to him, and it was this which appealed to David, although he also admired the breaker of conventions. He made a drawing of Robert in which his slacks and T-shirt were drawn in soft, loose outlines in contrast to the very finely and decoratively executed head, recalling the neo-classical drawing of the French artists, Ingres and David.

After New York Hockney went on to Los Angeles. David enjoyed himself and there were quite a few drawings of a handsome young blond boy, Paul

Miranda. But London was never far from his mind and he was back three
weeks later – to discover that Peter had started an affair with a young
photographer by the name of Eric Bowman. It was a terrible shock for David.
Most of his friends had never seen him so depressed. He kept on telling them
that something magical had left his life.

David's friends have always formed a sort of extended family, and that
summer, he, Peter and a whole group of friends, including Mo McDermott,
Mark Lancaster, Wayne Sleep, George Lawson, Maurice Payne, Ossie Clark
and Celia Birtwell, went to Spain together. David and Peter spent most of the
time rowing and everybody somehow got drawn into it. The break-up was
conducted in public – not that it was a clear break – 'We sort of drifted apart,
gradually, and after he was gone I realized how happy I had been with him,'
Hockney remarked sadly.

Back in London, he threw himself into work and even accepted a
commission for a portrait. The sitter was the director of the Royal Opera
House at Covent Garden, Sir David Webster. David rarely accepted
commissions – the exceptions were William Burroughs, J.B. Priestley, Isaiah
Berlin, Henry Moore and John Gielgud. David Webster was a jovial,
energetic man. He shared a grand house with his lover Jimmy Cleveland Bell,
who worked in advertising. They gave many glittering parties which David
enjoyed and it meant meeting some of his beloved opera stars. But he
couldn't paint there. As always, David's own taste was for simple,
unpretentious settings. (He once said of his lifestyle, 'I am actually still a
student, I just happen to have quite a lot of credit cards in my pocket.') So he
asked Sir David to come to his studio. He painted him sitting on a modern
chair in front of a glass table with flowers – a very different atmosphere from
Webster's home. It is a wonderful portrait of this ebullient man.

The loss of Peter brought to David for the first time the sense of an inner loss
of meaning. Half of him closed down. So many things stored between them

drifted away, vanished, but the sadness didn't shift easily and quite a few paintings refer to the loss of his lover – a pair of his sandals forlornly at the edge of the pool or a shirt draped over a chair. The disconsolate objects, arranged in several still lives, give off a feeling of deprivation. Earlier, David had painted a picture called *I Saw in Louisana a Live-Oak Growing*. A presage of things to come, it was based on Walt Whitman's poem of the forlorn tree, flourishing without a lover. Hockney's tree is painted upside down, 'to make it look even more lonely', as he says.

I SAW IN LOUISANA A LIVE-OAK GROWING

ALL ALONE STOOD IT AND THE MOSS HUNG DOWN FROM THE BRANCHES,

WITHOUT ANY COMPANION IT GREW, UTTERING JOYOUS LEAVES OF DARK GREEN

UTTERING JOYOUS LEAVES ALL ITS LIFE WITHOUT A FRIEND OR LOVER NEAR,

I KNOW VERY WELL I COULD NOT.

All around him the euphoria of the sixties had dissipated. The period of greater freedom and greater wealth was disappearing, and England's love affair with the visual arts had gone sour. The art market was in crisis, the bottom of the print market had fallen out and galleries were closing down; Robert Fraser in 1969, Kasmin in 1972.

David's perception of the world as a place filled with lovable, good people changed too. With astonishing honesty and few illusions, he took a tougher look at the world and himself. He often moaned that he was trapped on one side by commercialism – the big prices his work obtained seemed absurd to him – and on the other, by his popularity, much of it of his own making. It is one of the most endearing things about Hockney, that he is simply not interested in money and the prices his works fetch. With a detached attitude he accepts fame and wealth as an inevitable fact. 'If I run out of it I can always become a pavement artist in Paris,' Hockney has always been able to enjoy life on a simple level, regardless of how rich he has become. Bradford had taught him that.

But in this period, he was unsettled and moody. His friend, the painter Mark Lancaster, suggested that he might like to go to Japan and within a day David was decided. With his usual meticulousness, he worked out the itinerary and took Mark along. In November 1971 they set off from San Francisco. A drawing of Mark asleep in bed in the St Francis Hotel is the first of many; he drew Mark over and over again. On this first trip, David did not like much of what he saw, except for the temples. From Japan they travelled to Macao, Bali and Bangkok, both painters sketching constantly. Once in Bangkok they drew two rent boys making love; David also drew a picture of Mark and a boy in the nude. By the time they returned a month later, Hockney had filled several sketchbooks.

The filmmaker Jack Hazan had proposed to make a film about David. It was three years in the making, and much of it covered the period of the break-up with Peter. Hazan kept popping up in various places, filming David at work. He also filmed Kasmin, Celia, Henry, Patrick, Mo and, of course, Peter in various settings. David always thought that it would be a short documentary, the sort of thing the BBC had done in the past, not 'the two hours of weeping music'. It turned out to be a total exposé of his emotional life. *A Bigger Splash* not only showed David at work, but also his relationship with Peter, an almost fictionalized account of their break-up and the effect it had on Hockney and his environment. Many naked boys dove in and out of pools and took showers together. It also had plenty of nude shots of Peter, including one of him making love with a friend. Stunningly photographed, it became an instant success but Hockney felt betrayed: 'I was stunned and shattered,' was how he put it. He disliked having been made the centre of so much attention, and the flamboyant public figure overshadowing the artist. He felt that the film, however remarkable, had more to do with the filmmaker than with him. Most of his friends had never seen him so upset as he was about the film which he first saw at a private screening. After several years, he reflected, 'I don't think it could be repeated, because to repeat it you'd have to find innocent people. The people in the film were completely innocent, not realizing how it was being done.'[33]

In this period, he was sometimes seized by a sort of panic. He started work again on his painting *Le Nid du Duc*. It was supposed to show Peter looking at another swimmer in the pool. But Peter was no longer there. 'Le Nid du Duc' was the name of a property in the South of France, a magical place that belonged to the filmmaker Tony Richardson. A few years earlier Tony had bought a cluster of crumbling stone houses, while working with Jeanne Moreau, who lived at La Garde Freinet, a small and unspoiled village twenty kilometres from St Tropez. The houses were filled with actors, painters, writers and the wonderfully lively assortment might include a racing driver, John Gielgud, Tony's wife, Vanessa Redgrave, with their children Joelly and Natasha, Jack Nicholson, or a beach boy someone had picked up. Hockney had come here often, sometimes with Peter, Patrick Procktor, Geldzahler, Kasmin, Celia and Ossie, or later Gregory Evans. He had done many drawings and some paintings there which still hang on the rustic walls of the house.

Tony Richardson was a wonderful and generous host. Stars and local people who worked on the land all joined together for lunches and dinners which were taken under the big tree, with peacocks and ducks strutting about. Yolande, a lively woman from the nearby village, cooked large casseroles of Provençal food and entertained everybody with her stories. Tony was a mixture of Mephisto and Prospero, stage-managing everybody's visit – and, given the chance, their lives. He took real pleasure in mixing and matching people, regardless of background and sexual preferences, and many a couple got together or split up in those blissful summers in his house. With its feeling of carefree joyfulness, intellectual stimulation and general cheerfulness, it was very much a place to Hockney's liking, the sort of place he would have liked to have had himself.[34]

And so it is not surprising that the painting which marked more than any other the breaking-up of his love affair was done here. *Le Nid Du Duc* is an important painting in Hockney's life for various reasons. David had started it while Peter was still around. The figure looking at a swimmer is based on a

photograph he had taken of him in Kensington Gardens in 1972. The painting was a long time in the making and David took many photographs for it. He had even cut up a first version. Some of Hockney's paintings are done incredibly quickly; others can take years with David going back and back to them. *Le Nid du Duc* was one of those. David asked Mo McDermott to come with him to the south of France to stand in for Peter. He also took Peter's pink jacket. The boy in the water was another friend, a young photographer, John St Clair. David took hundreds of photographs of John swimming and Mo looking on. Hockney and Mo, as his assistant, worked with painful intensity for weeks on the painting, sometimes late into the night. It was finally finished in London and was sold in the States. David rolled it up and stepped on a plane for New York where it was shown with several other pictures at the prestigious Emmerich Gallery.

Places weave strange spells and some affect people in the most far-reaching ways. I had taken Lawrence Durrell's daughter, Sappho, to see the pool in Le Nid de Duc which she had seen in *A Bigger Splash*. In her posthumous journals I found the following passage:

> *The film which had such an affect on me – probably out of proportion with its true merit – was* A Bigger Splash. *The pool in the final picture haunted me. It was like looking down on my myth – the tiny slip of blue – the very scene which held so much imaginative meaning for me. Le point du départ. The pool belongs to Tony Richardson and I can visit it tomorrow to pay my pilgrimage. Something that Peter Adam had said earlier in the day came back to me like a perfume: 'Nothing is real outside the head; all is illusory except what is in the mind.' When one's world is polluted to the soles of ones shoes – then the mind must recreate a livable world. Hockney for me was one of those starting points for imagining a world one can taste again.*

When I told David about this passage he was deeply moved. The picture which signified so much of an end in his life had been the beginning for

someone else's. Alas, the healing power of his or any art is limited; a short time after the encounter with 'Hockney's' pool Sappho hanged herself.

David sometimes returned to California, but Los Angeles without Peter seemed to have lost all purpose. In London too he appeared confused; paintings did not work out as he wanted and he was still struggling with the double portrait of Wayne Sleep and George Lawson. David was still restless. But in the past his restlessness was brought about and nourished by curiosity, the desire for life, for seeing the world, for new stimuli. Now the restlessness was of someone having lost his way, not knowing where to turn. He did not like the way he painted and felt a prisoner in what he called 'the trap of naturalism'.

Also old patterns kept repeating themselves: there were far too many people, too many demands. There were journeys to Italy with Henry Geldzahler and a new French boy, Thierry. Soon they were joined by Mo and a photographer from L.A., Don Cribb. The group kept on growing until they reached the house of the writer, Gregory von Rezzori, author of *Memoirs of an Anti-Semite* and his wife, Beatrice Monte, who in 1966 had exhibited David's work in her gallery in Milan. However welcome these diversions were in helping to erase the image of Peter, he needed peace and calm. So by the end of 1973, in order to escape his state of sadness and confusion, David locked up Powis Terrace and escaped to Paris, for, as he said, 'I knew that I was at a crossroad of my life, and that I had to do something about it.'

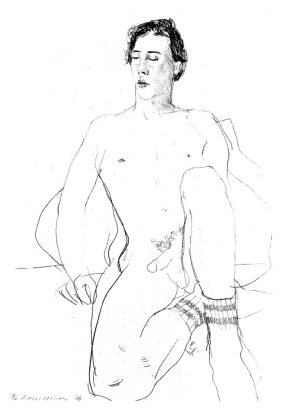

GREGORY WITH GYM SOCKS, 1976, LITHOGRAPH

In Hockney's life there was a new friend, Gregory Evans, a young man with frizzy hair and the American good looks David liked so much.

The end of innocence

'The end of innocence,' according to Henry Geldzahler, 'came for David actually with the death of Picasso in 1973,' undoubtedly the great hero of his life. In 1960 he had seen his first large exhibition of Picasso's work. He was totally mesmerized by it and urged everybody to go to the Tate Gallery to see it. I remember him going there almost twice a week. An important part of the exhibition was Picasso's paintings based on Velásquez's *Las Meninas*, and Hockney acknowledges that it was Picasso who taught him the freedom to borrow styles and themes from any source. Picasso's name is always cropping up in conversation, and in the year of his death David made two prints, *The Student: Homage to Picasso* and *Artist and Model*, based on Picasso's theme. In the first, echoing Picasso's Vollard suite, Hockney, the student, is carrying a portfolio to be inspected by his master. In the second, a nude David sits opposite a benign Picasso, dressed in a striped shirt he liked to wear. The two painters gazing at each other, their hands almost touching.

David spent two years in Paris. He lived in a flat tucked away in a quiet courtyard, the Cour de Rohan, behind the Odeon, 'just pass the statue of Danton,' he used to say, ' and you will find me.' The flat belonged to Tony Richardson and was once the studio of the painter Balthus. It was basically one large room and David worked there as he had done in the old days in Powis Terrace, only now he would not call either rooms 'a large space'. He actually found it was rather cramped so most meals were taken in small restaurants or at the Coupole, once the haunt of artists, writers and intellectuals, amongst them painters and photographers such as Kertesz and Man Ray. David had a few friends in Paris, most of them English or Americans, with the exception of Jean Léger and Alexis Vidal. David did not speak much French, although he

MY PARENTS AND MYSELF, 1975

understood quite a lot. He soon made new friends, among them the wonderful and eccentric Italian painter Lila de Nobili, who had done many memorable sets for the theatre productions of Luchino Visconti and Franco Zeffirelli. Hockney made a touching coloured drawing of this shy and reclusive woman who lived in three *chambres de bonne* with a horde of cats.

Early in the mornings David could be seen in colourful shirts with red braces, sitting in the Café Flore on St Germain des Près, reading the English papers, sometimes wearing a panama hat or a *beret de basque*. He became very fond of café life: 'You can have a plate of spaghetti and a cognac at all times of the day. You don't have that in Bradford or London.' Sometimes friends came over from London – Ossie, Patrick or Kasmin – and over a meal there was much talk about 'crossroads' and 'the necessary changes' he hoped to work out for his life and art. He also hung out with the odd American artists, Shirley Goldfarb and her husband, Gregory Masurovsky. Shirley was always dressed in black and wore heavy eye make-up. Most people ran when they saw Shirley

and her little Yorkshire terrier, but David liked her. 'For twenty five years she sat at the Café Flore with her little dog. She had such fucking cheek, she never had any money and she always ordered lobster. She really lived by her wits. She gate-crashed every party, sometimes the first one to arrive. I could never do that, I would die. But I like her, I even painted her. She was real.'

Much time was spent in the Musée d'Art Moderne or in the Louvre and David astonished everybody by how well he knew the paintings, some of them tucked away on hidden staircases or in small rooms where few people ever ventured. In his own work, friends seemed to have disappeared, replaced by many views from windows, sometimes in *contre-jour* and influenced by Matisse's marvellous *View From the Window* which David had seen in the small museum of l'Annonciade in St Tropez. But he had begun work on a large painting of his parents, of which he did several versions. It shows his mother looking at David whose image is reflected in a mirror, while his father sits motionless next to her. The double portraits of his parents are pictures of two people seemingly not relating, at least not on the surface: 'They were together 45 years then, my father often got a bit bored so he would grab a paper.' But David also tells us that 'theirs is the image of two people so closely linked that discourse is no longer necessary'. On a shelf are the volumes of Proust's *Remembrance of Things Past*: 'It's not that I wanted to suggest that we had Proust at home, but I had re-read it at that time and as it is about the passing of time and the memory which can stop this flow, I put it in. It was the mood I was in.'

His relationship with his parents, now in their seventies, was as strong as ever. His father eagerly collected any piece of writing that appeared about his son, while his mother always worried because her famous artist son looked like 'a tramp – two different coloured socks, people might think you are absent-minded.'

During these Paris years Hockney did a number of his best paintings and a series of big portrait drawings. The lithographs of his new friends were rather

academic: 'I like doing academic drawings from time to time, just to keep
you in training, many artists have done that in the past, it's a sort of exercise
to keep your line fluid. I think in a way you have to keep on doing it to be
able to reduce everything to a line as you work your way around a person.'
Hockney and Kitaj were both involved in a public debate about the
importance of the human figure in art, and both cited Picasso and Matisse as
the best examples of artists having been trained in drawing. 'You know the
great, great line artists, Matisse or Picasso, in that kind of Ingres academic
classicism often spent a day groping round with the pencil or the charcoal to
be able to reduce the essential to two or three lines. I noticed every time I
spent a month doing drawings like that, immediately afterwards you can draw
much quicker and your drawing is much more accurate about your feelings,
although it is much more economical.'

The portraits were very slowly executed and exuded a rare stillness, even a
detachment from his sitters, as it were, done by a man searching for his own
life. Many were of old friends, but there were also new names and faces: Jean
Léger, who David always claimed 'worked in a lipstick factory'; he was
actually doing package design for Helena Rubinstein. Nick Ray, Carlos, and a
young art student at the Ecole du Louvre, Yves-Marie Hervé, to whom David
was trying to teach some English – 'his English got rather better than my
French'. David and Yves-Marie spent a lot of time together visiting museums
and for a while he became his favourite model. Among the many rather formal
portraits of handsome young men, most of them self-absorbed in their own
good looks, is one of Yves-Marie sitting in a chair. Hockney always preferred
self-absorbed poses, the sitter looking dreamingly into the distance instead of
staring at us; we see Maurice Payne deep in thought, Ron Kitaj gazing into
the distance, Garry Farmer staring at the ceiling of Powis Terrace. Friends and
lovers caught sleeping, dreaming, thinking or reading, as in the painting *Model
with Unfinished Self-Portrait* from 1977 where Gregory lies asleep on a sofa in
the foreground while the artist concentrates on the drawing in the making in
front of him. For this painting, both Gregory and Peter had posed in the same

blue dressing gown – 'whoever was available', according to David.

One day Peter arrived in Paris, looking the very image of an American college kid, dressed in blue button-down shirt with a pair of crisp trousers. He well knew his effect on his ex-lover. David was wearing a baggy bowling shirt with 'Nutter's Taylor, Saville Row, London' printed on it in large letters as the two went out for lunch. David took photographs of Peter and Peter snapped back. And then he was gone again.[35] But he has never totally disappeared from David's life or work – few of his friends ever do. His face popped up in work from time to time, the childlike Peter having grown into an attractive young man gazing at us like someone from a different world. And as if to pay homage to Peter Schlesinger the painter, in a lithograph in sepia done in 1975, his head looks over a canvas with brushes. By then, many wounds had healed.

Hockney had not lost his sense of humour and he was able again to laugh with his friends. And a lighter mood returned to his work. In an etching, *Homage to Michelangelo*, we see two women passing a drawing. 'In the room/The women come and go/Talking of Michelangelo', as T.S. Eliot wrote and the painter tells us. In a witty way, Hockney pays homage to one of Michelangelo's most homo-erotic works, the study for the Battle of Cassina which celebrated the victory of the Florentines over the Pisans. Michelangelo had chosen to portray a scene in which soldiers bathing in a river are surprised when the alarm is raised. The naked men scrambled out of the river. With an almost voyeuristic pleasure, he painted the men in various suggestive poses, naked or semi-naked soldiers climbing into their clothes. Of course both Michelangelo and Hockney knew that the Battle of Cassina was also a reference to the famous classical band of Thebes consisting entirely of male lovers. Many painters throughout history had copied or cited Michelangelo's work as a hidden homage to homo-erotic love, but by the time of Hockney's homage there was no longer a need to be so furtive.

In Hockney's life there was a new friend, Gregory Evans, a young man with

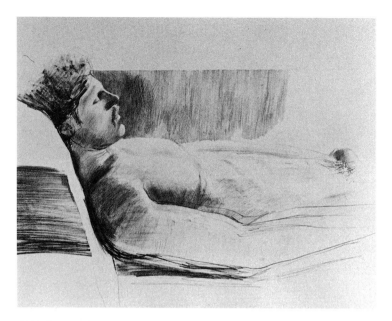

LARRY, FIRE ISLAND, 1975

frizzy hair and the American good looks David liked so much. Gregory was delightful, with an infectious smile and, although different in looks and temperament, rather reminiscent of Peter. He was a student of textile design and had come to London in 1973 with his lover Nick Wilder. Nick had insisted that he meet his friend, David Hockney. As it happened Gregory was also in Paris at this time and lived just around the corner from David, in the rue du Dragon. It was not the *coup de foudre* he had felt when he met Peter. David later explained, 'I liked him, we saw each other a lot, and suddenly a year later I realized that I was keen on him.'

In Paris during 1974/75 Hockney had also renewed his interest in the nude, and he took many Polaroid pictures of Gregory. He even allowed an English gay magazine to publish a number of sexy Polaroid pictures showing himself,

Gregory and a friend from Los Angeles, Mark Lipscombe, jumping in and out of the bath and frolicking around in the Paris flat. Over the years David had tried to persuade most of his friends to pose for him in the nude; many of these drawings were shown at the Left Bank *galerie*, Claude Bernard, with a *vernissage* attended by *le tout Paris*. Private happiness was so often linked with public success, and in 1974 Hockney also had a very successful retrospective at the Musée des Art Décoratifs that showed forty-five paintings and 105 drawings. They proved Hockney's skill not only as an accomplished draughtsman, at home in any medium, technique or style, but also showed his eclectic range from loosely, almost casually executed, jottings to highly contrived compositions. Stephen Spender had written the introduction to the lavish catalogue and *A Bigger Splash* was also shown in a cinema, and suddenly it was a bit like the old days. Hockney was a celebrity again surrounded by too many people. So, once more on the run, he decided to move back to London and Gregory came along with him.

In the summer of 1975 Henry Geldzahler took David to Fire Island. David had never been to 'the Island', and he loved it. Fire Island had been magic for many homosexuals since the fifties. A narrow stretch of land, sixty miles from New York, there were no cars and no roads. Boardwalks made from bleached planks linked the houses of the small communities, among them two gay communities, Cherry Grove and the slightly smarter Pines. David stayed in the Pines in the house of a friend, the banker Arthur Lambert. Many pretty boys from New York went to the island, especially on weekends, when the small beachhouses were full to the brim. People literally everywhere. Everybody was gay, even the police, boys walked around hand in hand and, if they wanted to, made love openly. Men danced together at the famous tea dances, and the parties in the houses never stopped. It was the most liberating, soul-strengthening and friendship-forming place imaginable. But it could also be a place of sadness and solitude. As quickly as liaisons were formed, just as quickly they broke up. With the cruelty of the young and successful, everybody wanted to score in a race for the most beautiful, the

sexiest, the newest. With so much effort and energy devoted to hedonism
and narcissism, it was not a place for the elderly.

David spent 'a lovely month' there. It was precisely what he needed at that
moment in his life. He romped about on the island dressed in white baggy
trousers and matching white jacket, looking rather too smart for this place.
There is a wonderful photograph of David and Henry dressed to the nines,
lounging in deckchairs holding up parasols, looking more like passengers on
an old-fashioned steamer in the twenties than like visitors to an island were
casualness and general undress was the norm. A whole album was filled
with photos of handsome and bronzed boys David snapped at the beach. He
was also photographed by Robert Mapplethorpe, sitting, yawning –
'Certainly not of boredom rather out of excess of life,' he said when I asked
him. The drawing, *Larry, Fire Island 1975* shows a handsome sensuous nude,
Larry Stanton, a friend of his host and a painter, fast asleep on a sofa. It is a
telling testimony to a time of liberating hedonism.

Back in England and just at the right moment, a new venue of artistic
exploration opened up. The director John Cox asked Hockney to design the
sets for Stravinsky's, *A Rake's Progress,* the libretto by W.H. Auden and
Chester Kallman. As usual, Hockney immersed himself conscientiously and
methodically in the world of the work: 'I found the music quite difficult
really at first, but the more I listened to it the better it got, and I never got
bored with it.' Loaded with a lot of old engravings and a record player, he
and Mo travelled to Los Angeles where Stravinsky had composed the work
between 1947 and 1951. 'I love authenticity of that kind, you sort of walk on
historical ground, as I always also like to find out as much as I can about the
subject of the opera and the world it was created in.' They locked themselves
away in the Hotel Château Marmont, a wonderful mock-Gothic relic from
the times of the great Hollywood movies and a favourite place for artists.

Working on a stage set had a liberating effect. As always, a new medium fired

David to experiment and filled him with creative vigour. He designed backdrops using cross-hatching techniques, much used in eighteenth-century engravings. He then coloured the lines with cheerful reds, greens or blues. The decorative graphic lines were not only effectively used on the walls but also on the costumes and furniture. 'A painter tends to think in pictures, all my sets have depended on a lot of drawn things rather than objects you move about on the stage. People are used to seeing those lit and thrown shadows. I do not need that, I just draw the shadow in. People think that it is less real, than let's say a table on stage, which is of course a false assumption. If you paint a table or stylize it you can make it more real.'[36]

A Rake's Progress, soon to be known as 'Hockney's Rake', opened at the Glyndebourne Festival Opera on the 21st of June 1975. For the opening, David wore a dinner-jacket with a very large colourful bow tie. Peter Langan, the owner of two of London's most fashionable restaurants, Odins and Langan's Brasserie, threw an *al fresco* banquet for at least 150 of David's friends. A table was set up by the lake and handsome Spanish waiters served delectable fare plus masses of champagne. Hockney had designed the menu, labelled *An Evening of Excess,* featuring a picture of Peter Langan and a French wine merchant.

David loves food, fancy hotels and fashionable restaurants. His menu designs have graced some of the most 'in' restaurants such as *The Neal Street Restaurant,* opened by Kasmin, the designer Terence Conran and the delightful Italian master chef Antonio Carluccio, the very chic *Mr Chow in Knightsbridge,* and for *Ma Maison* in Los Angeles and *La Chaumière* in Paris. It was obviously 'the thing' to have a menu designed by one of the most fashionable artists, and people kept pinching them – everything Hockney did had become collectable.

At this time there were changes all around. He sold Powis Terrace and bought a new studio to work and live in. It was one of a row of smallish two-floor studio houses in Kensington, giving out onto a narrow central garden.

His Pembroke Studio was basically one big room with a kitchen and a smaller bedroom above. Under the large window stood a glass table with a few beautiful objects, such as a Lalique vase. There were also two wicker chairs painted blue, and his easel with an array of neatly arranged brushes. On the walls and in the small gallery above hung the miscellaneous paintings he was working on or had just finished. People dropped in for a chat or a cup of tea, charladies' tea as he insisted on calling it. Many arrived unannounced and, with his customary politeness, he bore it. Once again he had a new 'secret' telephone number, which soon made the rounds.

The indefatigable Nikos Stangos had finished recording his mammoth interview with Hockney, twenty-five hours of taped conversation which resulted in Hockney's first autobiography. And, as always, David, who so freely and so openly talks to people, was shocked and surprised by 'how much he had revealed'. It was published with a warning – 'It is a very good advice to believe only what an artist does, rather than what he says about his work.'

Gregory was living in Spain, but visited London often to be with David. Between 1976 and 1978 Hockney did many paintings and drawings of his new lover – among them *Gregory Reclining, 1976* and *Gregory with Gym Socks*, a revealing nude of the same year with David's favourite erotic attribute.

But David was soon restless again and the old pattern of moving between Los Angeles and London re-emerged. Los Angeles brought forth a feverish burst of creative activity. Solace had come, as it often does, from work and he had banished most of the old ghosts. He is one of the great bouncers-back and by 1977 the old buoyancy and unguarded spirit was apparent in his life and in his work. He had rediscovered his old ironic tone, and some of the portraits reflected this, like the one of Henry with a big cigar. 'Henry was always willing to pose, the minute I took out the pencil he sat up. One day I thought, "Why should he think that I always draw him," so I drew a Mickey Mouse while he sat there rigid. It's naughty, but I could not resist it.' The

gaiety of a child who had not been taught to behave was back again. He also took up large-scale lithographs of friends, still academic with a great deal of detail, as they had been in Paris. The sitters looked rather serious, like the one of Joe MacDonald, a meticulous drawing of the handsome young man seated rather formally on a chair.

David considered settling permanently in California. He first rented a house in the hills above Sunset Boulevard and a studio on Santa Monica Boulevard, but in 1978 he moved up into the Hollywood Hills. He had found a small cluster of unpretentious wooden bungalow-type houses with a garden in a small street and he still lives there. Gregory came to join him. 'I was quite in love with Gregory, but of course it was a much more loose relationship than with Peter'; an arrangement which suited them both. Gregory was much more independent than Peter had been, at least in the beginning, and was careful not to be drawn completely into the 'Hockney court'. David, in any case, was on guard; he did not want to be hurt again. Gregory was also willing to work as David's assistant and would become involved in many projects for the stage and for exhibitions in the years to come. He was totally unimpressed by David's fame and has remained his loyal and always frank friend to this day.

To reach the Hollywood hill house, one drove up Nichols Canyon, a narrow valley and one of the loveliest drives. On the crest was Mulholland Drive, a meandering road looking down on Los Angeles, which at night was like a twinkling carpet. David's house, nestling in the hill, is only ten minutes from Hollywood, but one has the feeling of being in the country. In the large open-plan living-room he had hung a painting of Laurel and Hardy done by his father. There was little furniture – a big plan-chest and a couple of armchairs. Outside the sliding windows was a large wooden deck overlooking a pool, surrounded by tall palm trees. It was a warm and welcoming place. Hockney took up once more one of his favourite subjects, pools, but the new pool pictures were different from those from the sixties. The earlier ones were largely concerned with the bathers and the effect they had on the surface; in the new ones, the

surface of the water and the effect of the sun on it had become the main subject. Howard Hodgkin and Peter Schlesinger came to visit and so did Celia Birtwell and Ann Upton. Hockney did some large lithographs of his two enduring female friends. He drew Ann and Celia in an intimate, tender way, making-up or just lounging about. The influence of Bonnard and Toulouse-Lautrec, whose works David had been studying for a French theatre project, could be clearly felt. These lithographs, despite their often shamelessly decorative manner, had a freshness and directness which some of the drawings of boys lacked: whereas the boys often avoided the onlooker's gaze, Celia looks straight at us, as in the charming *Celia Amused*. 'I have done lots of drawings of Celia, she is a wonderful model, she is very quiet and patient. When you are drawing a tenseness is building up inside you as you go along looking for things. I sometimes do fifteen drawings in order to have six good ones. Of course many are done very quickly and in a very tense way, so it is nice to draw someone so totally quiet.' In 1983 Ann married David Graves, who had worked at Alecto and had become Hockney's assistant. As so often, Hockney was a witness at his friends' marriage. This time he organized the marriage ceremony in Hawaii and the rather kitschy ceremony was captured in a photo-collage, *The Hawaiian Wedding*. David and Ann lived in California.

Peter was not out of David's life, but their relationship was in calmer waters. In 1978 the two travelled with one of David's friends, Joe MacDonald, to Egypt. It was a funny and exhilarating trip. The three had joined a group of mostly middle-aged couples and some pyramidologists from Tennessee. Peter and Joe put their noses up at what they called 'those hick-Americans', while David loved his travelling companions. 'They were not the sort of people who travel to the Costa Brava and get drunk on cheap wine, they came here to learn something!' he reprimanded his friends. David never went anywhere 'just for pleasure'. Even on Fire Island he had studied Wallace Stevens' poems which inspired his beautiful series of twenty etchings, *The Blue Guitar*.

Watching Hockney at work

Whenever he came to London, Hockney was much in public demand, making a programme about Renaissance painters for BBC Television and selecting and exhibiting his favourite pictures from London's National Gallery. He chose Degas, van Gogh, Vermeer and Piero della Francesca, all masters of the human body, and captured the event in a painting called *Looking at Pictures on a Screen,* which showed the image of a man looking at his selection. The onlooker was Henry Geldzahler.

Hockney's relationship with the great masters is central to his life. He spoke of them as if they were old friends. In late April of 1979 Hockney, the painter Prunella Clough and myself travelled to Holland to make a short film for the BBC in the series *One Hundred Great Paintings.* His choice this time was van Gogh, his interest in the Dutch master dating back to the late seventies. As always, his imagination was fired and in 1978 he executed a number of drawings influenced by van Gogh's *œuvre.* For our camera he stood in the Kröller-Möller Museum in front of Van Gogh's *Café in Arles* in his baggy trousers and colourful sneakers: 'The Dutch call him Van Chgoch, the Americans call him van Go, I will just call him Vincent.' Within minutes, he made us see the brush strokes and the speed with which the painting might have been painted. Hockney allowed the viewer a rare insight into the mind of another painter: 'Vincent painted thousands of oils and made all those wonderful drawings and then he wrote all those letters, and at night after painting, he cleaned all his brushes, so what's so wonderful about his life is that every minute is accounted for.' It was a painter's loving laudation to another.[37]

That night in the hotel we talked about the views of artists on artists, and how

they would always see something in a work of art which many art historians or critics would miss. Hockney is convinced that an artist connects back to other artists in a very special way, 'because they have a deep urge to communicate.'

Six months later I asked David to let me make a full-length television documentary about him. It was to be part of a series, *Artists At Work* which I was making for the BBC's Omnibus programme. The hour-long documentaries observed various artists at their work and I had already made programmes about the composer, Hans Verner Henze; the novelist Lawrence Durrell; filmmaker, Luchino Visconti; the playwrights Lillian Hellman and Edward Albee; and profiles of the actresses Lotte Lenya and Jeanne Moreau. With the exception of a short film on Man Ray, I had not yet dealt with a painter, so Hockney was the obvious choice. Knowing of his resistance to the Hazan film, I decided that *David Hockney At Work* would leave out most of the personal details of his life and concentrate on the artist as he was working in different media – painting, drawing, photographing, printing and set designing.

I filmed him over the next weeks. A natural teacher and communicator, he is never disturbed by someone watching him. No one is better able to analyse his own work in simple comprehensive terms. He makes the viewer part of his own creative process, always drawing him in. We started in London by filming the exhibition, 'Travels with Pen and Ink', charting the path of his life during the past twenty years, which was showing at the Tate Gallery. Hockney was undeterred – even excited – by the presence of the camera; he walked through the rooms, pausing here and there, commenting, discovering, delighting as always in his own work, an amiable clown in funny baggy trousers and colourful cap. 'I like flowers', he suddenly said, 'they are very difficult to paint. In the old hierarchy of skills, faces are the most difficult, hands are next, feet, the human body and after that flowers.'

We spent a few days filming him in his Pembroke studio where he was working on the sets for the Metropolitan Opera in New York of a triple bill

of Francis Poulenc's *Les mamelles de Tirésias*, Satie's *Parade* and Ravel's *l'Enfant et les sortiléges*, three works created in Paris during the First World War. The imaginative English director John Dexter had put them together to demonstrate how art is able to overcome the horror and chaos of war, a theme that also greatly appealed to Hockney. Here again he revealed his theatrical genius; every drawer, every space on the wall was filled with sketches and crayon and gouache drawings in the manner of Dufy, Matisse or Picasso. He loves working in the theatre: 'It is quite a different experience from painting. You know a painter really has quite a solitary existence. You have to be isolated from the noise of the world, and you spend days on end alone in your studio. In theatre you work with other people, you test your ideas out on others. I like that, especially when I work with friends.' Hockney worked closely with the director and involved his close friends or assistants to work out the complex details of set and costumes.

Hockney's interest in stage design went back to 1966 when he had done his first set design for Alfred Jarry's *Ubu Roi*, whose anarchic character suited his temperament. It was a lively production done in the small Royal Court Theatre in Chelsea, directed by Ian Cuthbertson. Hockney's cartoon-like anti-naturalistic sets were a humorous framework of the riotous happenings on stage. Over the years he has designed sets for *The Magic Flute, The Rake's Progress, Tristan, Pelleas and Melisande, Die Frau ohne Schatten, Turandot* and an evening of three works by Stravinsky. He also designed the backdrop for a Roland Petit ballet and the sets for a gala evening of scenes from various operas which he turned into a video tape. 'I have always been a real fan, a sucker for music,' he exclaims, 'I love big music like Wagner.' The first time David went to Bayreuth to hear the Ring, he was totally transformed. 'It was a marvellous experience, the whole town was just living for the opera, you knew exactly why you were there, with photographs of Wagner and Karajan in every shop window.'

As always, working for the opera provided an occasion to immerse himself in

history. He had asked Gregory to become his permanent assistant, an arrangement which suited them both well. The first production of Stravinsky's ballet *Parade* in 1917 had been a collaboration of some of the greatest talents of the time. Based on a story by Jean Cocteau, it had been created for Diaghilev. The choreographer was Massine and the set was by the young Pablo Picasso. Hockney began his study of the history of the Ballet Russe. For the Poulenc opera, which had a libretto by Apollinaire, he designed a number of backdrops influenced by old seaside postcards, with 'French' brush marks reminiscent of Dufy. The costumes were influenced by the famous dress designer Paul Poiret. But the piece he liked best was the Ravel opera, based on a story by Colette about a naughty boy who breaks his toys and smashes the china. 'I guess Ravel and I are children at heart,' David said, 'and we both believe that the world can be transformed by childlike wonder.' In his Pembroke studio he built a toy stage set and sat in front of it, like a child, raising and lowering the curtain and moving small figures around. The set had all the magic of a toy theatre with a giant teapot and little cubes with letters and numbers painted on it, which were moved about by Punchinellos. The little theatre even had a tiny lighting set which allowed David to change the lighting. As always, people drifted into his studio and he sat them in front of his little theatre, put on the Ravel music and told them the story:

It is about a naughty boy, who says 'I am fed up being good, I want to be wicked'. So he picks up the poker and smashes the teapot. The teapot and the cup do a little dance, and naturally being a black Wedgwood teapot it sings in English, and the Chinese cups sing in Chinese. The opera is full of childlike wonderment. In the garden is a great big tree, which sings: 'You wretched boy, you stuck a knife in my side.' And a dragonfly scolds him too. And they all run around and someone treads on a squirrel and damages its foot and when the boy sees this, he takes off his tie and bandages up the squirrel. And then they all say, 'Maybe he is not so bad after all.' And the last words are, 'Maman', like it's all in a dream.[38]

David is a romantic, his belief in the goodness of people is totally genuine, and he adds, 'I totally believe in the story myself that somehow there is something good somewhere in us. I think there is real hope for us wretched people.'

The triple bill opened in New York on the 20th February 1981. Its immense success was greatly due to Hockney's stage magic, but he refused to take a curtain call. He sat in the stalls dressed in a white suit, with Divine, the drag artiste who starred in John Water's underground films, such as *Female Trouble* and *Pink Flamingos,* next to him in full regalia. When the audience spotted Hockney, they broke into thunderous applause.

In 1979 David spent two months in London, working fiercely and still making time to see his friends. He seemed not to be distracted by the endless cups of teas and the casual chat which filled his studio, and would manage to finish a new canvas in between friends' visits: 'I had not been using oil for a long time, so I got very excited.' All around the walls were colourful oil paintings, relating to the operas, *Ravel's Garden,* and *Picasso's Harlequins.* As so often, working in one medium had spilled over into another. Every corner of his studio was now filled with exuberant new paintings on the theme of dance and music. From the small Gallery hung *Ravel's Garden, Waltz,* an adaptation of Picasso's original curtain for *Parade* and a large *Harlequin* doing a handstand. The boldness of the design and the brilliant colours of no less than sixteen new paintings filled the room. 'I keep getting more and more excited by colour. That's what California does to you. In California I see bright yellow and orange, blue and green. It drags you in, colour, suddenly discovering it and all its possibilities. I am turned on by it. In England everything does look grey, and I get grey, everything gets greyer. Now I must go back and use California and use Californian life as a subject.'[39]

A few days later he was back in Los Angeles and I followed him there. Not for a long time had he been so excited by work. To escape the social rounds in his house in the Hollywood hills, he spent a lot of time in his studio on

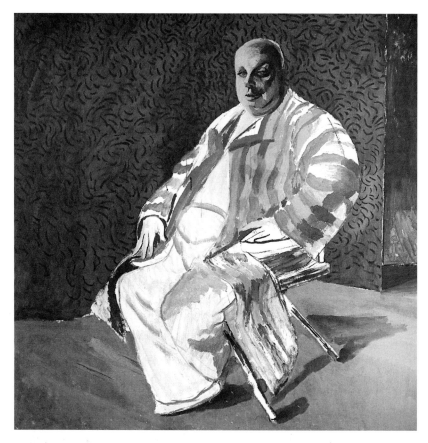

DIVINE , 1979

'You can kill a painting or it can die on you, but
then you can also bring it back to life.'

Santa Monica Boulevard. What was striking about Hockney's studio was the meticulous order. The brushes stood neatly cleaned in large glass jars or pots, the thick tubes of paint were lined up in neat rows. On the wall hung several large unfinished paintings: the double portrait of *The Conversation, Santa Monica Boulevard* and *Divine*. Experimenting with new colours, acrylic paint allowed David to work more spontaneously, more freely and more quickly, which produced the liveliness he was looking for.

There were several paintings with large single figures reminiscent of Matisse's single portraits. In the portrait of Divine he caught perfectly the character of the outrageous drag artiste. It was actually Don Bachardy who had first done a portrait drawing of Divine and as he had expressed the wish to meet Hockney, Don had taken him to meet him. Hockney painted a large figure, dressed in white trousers with a blue and pink striped coat sitting on a folding chair in front of a dark blue background with red squiggles.

The most impressive picture was a twenty-foot long canvas, covering almost an entire wall, which showed the happenings on the street through the open door. Hockney had begun *Santa Monica Boulevard* in the autumn of 1978. He worked at the painting bit by bit, testing the new colour: 'I don't mind working on it for three or four years. The more time you spend on it the more you change it. I sometimes linger too long over a painting. I put it away or just let it hang there. Some paintings I change and change again, so then they lose spontaneity or direct expressiveness. People think that if you spend four or six months on a work it must be good and if you do one in a few days it cannot be a great work of art. I do not have the same problem with drawings. I wish I could paint like I draw. There are of course technical reasons, but also emotional ones. You can kill a painting or it can die on you, but then you can also bring it back to life.'[40]

Much of the painting was based on photographs he had taken of the street life with his new Pentax camera. When I arrived with my crew, David stood on

top of a large ladder painting in little flags he had seen at a car dealers that morning. 'Santa Monica Boulevard is all façades, painted bricks, painted crazy paving. Nothing is what it seems to be. But what I love are the hustlers, they look like ordinary hitchhikers, but they are hustlers. And then there are these wonderful old ladies with their shopping bags not noticing anything, smiling at the boys like their sons.' As if oblivious to the camera, he went on painting and talking at the same time. 'In L.A. you can live in an area where you almost never see a straight person, many boys in states of half undress waiting at tables or turning tricks. That's quite amusing, nothing like this exists back home, but I do not like ghettos and homosexuals are far more varied in their lifestyle than what runs under the label of gay, especially American gay. Life is so much richer, fuller.' Then he took a piece of transparent Mylar on which he had painted the figure of a hustler in tight shorts and sunshades. He kept on shifting it along the large painting to find the place where it would best fit into the composition. Later in the day, to amuse us and himself he asked some of the boys in for a cup of tea, and watched their reaction to the painting.

It was an odd work. His engagement with the subject seemed not to be matched by his engagement with the actual painterly surface, which had perhaps been worked over too much. Somehow it did not come alive. It was his first multi-person picture and on an unusually large canvas. 'I feel lost with that painting,' David remarked. His new assistant, Jerry Sohn, was later told to destroy it, and only bits of it survive.

Our filming moved to the house where David had asked Mark Lipscombe and a few other friends to come and pose. He wanted to re-create for our film crew the process that had led to his pool paintings. When we arrived, four or five of his American friends were already frolicking stark naked in the water, the usual array of beautiful naked boys diving from the board, floating happily on rubber mattresses or just sunning themselves languorously, not at all bothered by my camera crew, and David with his camera, directing them to

swim in and out of the shadows. 'Where in the world can you get this kind of naked hedonism?' beamed David. It was just like his paintings. 'There is something about a body swimming under water. The transparency makes it so elusive, difficult to define, quite erotic really. It's a subject that has got a lot of richness in it. You can look at the reflection of the body in the water. And the water is dancing all around it, all the shapes are dancing. The body is still there but the shape is distorted. And as a painter you invent in your head all sorts of terms and devices to depict the interlocking shapes.' David became excited by us filming the bathers while he took photographs of them. 'Water is such a phantasmic subject for me. It's so elusive, there is something about the transparency that you can't quite define, especially in words, but as a subject for painting it has a richness, it always reflects something quite beautiful.'

Hazan's *A Bigger Splash* had given me the idea for a slow-motion sequence of a nude boy diving into the pool, creating the famous splash. I had intended to call my documentary *The Smaller Splash,* but it ended up as *David Hockney At Work.*

David enjoyed the filming. He made a drawing of Gregory and one of me, talking succinctly and lucidly all the while about his approach to the media of drawing. The peacefulness of those Californian days was only sometimes interrupted by calls from John Dexter at the Metropolitan Opera, informing him of trouble with the triple bill. John was very fond of David and they liked each other's lively imagination and artistry, which made working together very stimulating. Rudolf Nureyev had been asked to choreograph *Parade.* David and Nureyev had known each other from London and David had drawn the dancer in 1970. Although working with Nureyev was never dull and always challenging, he was known to be difficult and rude. The trouble was he could never leave himself as the star at home and for someone like David, who is always very civilized and tries to hurt people as little as possible, Rudolf's rudeness must have been very trying. David, who hates constraints except those of his own making, went to New York and the two had a blazing row, after which Nureyev left the project.

DAVID HOCKNEY AT WORK, 1979

Climbing the peaks

Hockney's public success climbed to dizzy new heights. In 1981 Gregory, Stephen Spender and David went on a trip to China. David had begun working on another triple bill of works by Stravinsky – *Le Sacre de Printemps, Le Rossignol* and *Oedipus Rex* – for the Metropolitan Opera. The director was once more his friend John Dexter and the conductor James Levine, a team Hockney felt very comfortable with. *Le Rossignol* is based on a Chinese fairy tale and David had already spent much time in the Victoria and Albert Museum, photographing details on Chinese vases. The trip to China provided further inspiration. He photographed and made a lot of elegant and loosely executed drawings of joyous simplicity, inspired by Chinese brush work and the colourful spirit of some of Picasso's sketches, just as his earlier trip to Japan had prompted him to execute images of rain and water in the style of the great Japanese printmaker, Hokusai. He also used quite a lot of watercolours, a medium he had so far not been very happy with. Nikos Stangos had asked David to keep a sort of record. The result was *The China Diary*, with text by Stephen Spender and Hockney's eighty-four colour drawings of the happy and memorable weeks.[41]

Some times in 1982 a new friend from New York, Ian Falconer, joined the household in the Hollywood hills. David had actually met the nineteen-year-old art student in New York in 1980 through Henry Geldzahler while rehearsing the triple bill. Ian had the usual appeals for David: good looks, a lively and boyish charm and a crown of blond hair.

Two years later Ian moved to Los Angeles and David enrolled him in the local art school. The new arrival seemed not to disturb arrangements:

'Gregory lived downstairs and Ian and I lived upstairs,' David confided. Extended family life suited him and Hockney is not really possessive. He wants people to be happy. 'We all got on well together,' was the verdict when questioned about the sometimes unorthodox pattern of his life and travels with friends or lovers, past and present.

The new mood may be best described by the fact that the houses were suddenly repainted in bright colours inside and outside. It was like a children's playground; one wall was green with a pink edge and there was a lot of red and blue and some bright yellow. Even the furniture did not escape, nor did the bottom of the pool. It was just like living inside a Matisse painting – or a Hockney! A mobile of colourful fish that could be made to move electrically hung from a tree in what David cheerfully calls 'his aquarium'.

David was happy. Peter Blake came to Los Angeles and when he returned to London, he did a witty painting inspired by Courbet's *Bonjour Monsieur Courbet*. It showed David on the colourful beach in Venice meeting Howard Hodgkin and Blake himself. The two London painters humbly bow, their caps in their hands to an upright, T-shirt-clad Hockney.

David did a lot of erotic drawings of Ian at this time. 'I need someone sexy around me and anything with Ian was a tremendous turn on, just looking at him.' Some charcoal drawings included David himself making love to Ian. These were sketches for an oil painting that never materialized.

'In the past,' David had told me in 1979, 'I have always shied away from looking at myself too closely. As I do not like confrontation, I sometimes refuse to look too closely into my life. I do not know why, people have always told me that I have an innocent approach to life. I do not think that is quite true, but as time goes by, I will have to face things anyway, why clutter my life with it now?' And yet in the following years, the numbers of self-portraits increased. He had sporadically painted himself throughout his career

as a sort of stock-taking. But in 1983 he did about thirty charcoal drawings of himself of an astonishing honesty and seriousness. While the double portraits of his friends conveyed a psychological insight merely by the *mise-en-scène* in the paintings, he now delved under the surface. The results were a picture of a man who was self-absorbed, as if questioning the world, and at the same time withdrawing from it. He was battling with the passing of time, realizing that ageing meant a stronger defining of his goals – and the happy resignation to the large issue of death. For those who knew his often aloof and vulnerable side, these portraits came as no surprise.

For David, everybody must always be a part of his success, his fame and his fortune. He is like a lottery winner who wants to share his win. He never tires of passing on his experiences, his enthusiasm for his work, David is the perfect cicerone. He likes to tell you about the most wonderful hotel he knows in Cairo or where to eat the best food in Greece. He wants everybody to join the fun. But one night when he was alone – Ian had gone to a night club – he spoke to me for the first time about the problem of loving people so much younger than himself: 'I always want everybody to have such a good time, and somehow you pay for it.' It was the first inkling of a feeling of despair and dejection that would mark his later years.

David took his new lover abroad, showing Ian the towns, the museums, the restaurants he loved. They first travelled to London and he introduced Ian to his friends. Ian actually figures in a large painting entitled *Four Friends* which David started in London in the summer of 1982. It was a compilation of eight separate panels and showed Celia Birtwell, David Graves, Stephen Buckley and Ian, each in front of a different background. After London Ian and David travelled to Paris, where they stayed in Jean Léger's flat. Ian, as so often the case with his friends, had become involved in David's work, especially with the Polaroid pictures.

Hockney's photo pictures and Polaroid compositions were shown in the

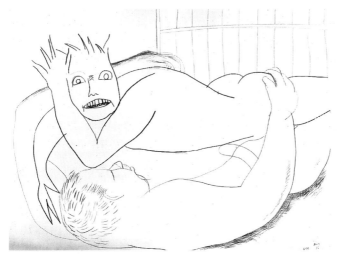

IAN AND ME VI, 1983, CHARCOAL

Pompidou Centre in Paris and later in London, New York and Tokyo under the title 'Drawing with the Camera'. They attracted wide public attention, not least for the glimpses they allowed into Hockney's life and surroundings. In a lecture he gave at the Victoria and Albert Museum in 1983, he explained that he wanted his photo collages to give as many perspectives from as many positions as possible, just as the cubists had done in their paintings. The preoccupation with photographic images took on a large significance: Hockney's dealers smelled money and photographs were offered for sale. At a certain time, David Graves employed ten assistants to cope with the reproduction. It was the beginning of David's subversive attitude to the art market and the gullibility of his collectors. He had a stamp made that read: 'Not for investment. Buy only for pleasure'. Some critics were mistrustful of his photographic works, others loved them, but what was more important, master photographers such as Henri Cartier-Bresson expressed his admiration, and in 1986 Hockney was given an award from the prestigious International Council for Photography in New York.

His assistants-cum-friends, Mo, Ian, Gregory, Jerry Sohns and David Graves, tried to cope with the demands for exhibitions. From 1983 to 1985 the spectacular exhibition of Hockney's stage designs, *Hockney Paints the Stage* toured internationally. Hockney also took part in a London show of *The Male Nude – a Modern View*, to which he submitted nine works, including nudes of Ossie and Ian, plus six delightful drawings called *Waking Up*, of David and Ian, two cuddling figures in crumpled sheets, the happiness and the tease of two lovers in the morning, the painter looking like a horned devil behind the naked body of his lover.

For the Christmas edition of French *Vogue* of 1985, Hockney was asked to design 'his own edition', an accolade that had previously been awarded only to Marlene Dietrich, Franco Zeffirelli, Miró, Dali and Alfred Hitchcock. 'I am not interested in fashion or any of that chic stuff, but I thought I'd give it a try. I did 40 pages and the cover, I thought they would never take that.' *Vogue* loved it. The cover showed Celia's face, and he had written his text with coloured pencil in longhand, which they reproduced. His last words were *'Paix sur terre'* – peace on earth. For the illustrations he used his photo-montage technique and created fractured images of his friends and his favourite places and objects like the little Place de Furstenberg, the chestnut trees in the Jardin du Luxembourg and the chairs in the Tuileries.

For his fiftieth birthday in 1988 there were retrospectives of his work in Los Angeles, New York and London where he appeared on the cover of the *Sunday Times Colour Supplement* with photos taken by Helmut Newton. The famous photographer and his wife June became friends in the years to come and, of course, were painted. Adverse critical reactions to his work – and there were some – were offset by the hundreds of thousands of people that queued to see his exhibitions. But Hockney has never deluded himself about his art. He is aware that some of his works, especially his oils, are often more remarkable for their images than for their execution. Often painted in a great rush or overpainted too often, they sometimes lack the painterly quality he

likes to achieve, and look better in reproduction than in actuality. Some
critics felt that Hockney referred to other painters a great deal; the colour of
Matisse, the cubism of the ever-present Picasso, loomed large in his canvases.
In an attempt to address his problems as a painter, Hockney withdraw
increasingly into a private dialogue with the artists of the past, but many felt
that his preoccupation with the formal problems of space and colour made
him lose spontaneity and expressiveness. Many missed the breathtaking
facility and verve, the invention of jokes and puns of the early years. It is
certainly true that his earlier works, concerned with his odd, burrowing inner
life, with sex and the artist's emotional response to his immediate
surroundings, had a confidence, freshness and directness his later canvases
sometimes lacked. He has been accused of constantly changing his technique,
from etching to drawing, from photography to oil, from collages to stage
design. But he is undeterred by this lack of unity. He is an artist who
demands the freedom to depict the world in a multitude of ways: 'How can
anybody say that such a complex thing as life or nature should only be shown
in one particular way.'

Neither success nor adverse criticism has taken from him his unshakeable belief
in the artist's right to determine his own style, technique and subject matter.
Of course it hurts him that, as one of the most successful and acclaimed artists
of the post-war years, he is also one that the critics constantly denigrate or
even vilify. His very success has made him suspect in the eyes of many,
especially in England where public success is always seen as detracting from
seriousness of purpose. But he shrugs it off as a sign of the mean-spiritedness of
critics, 'I don't give a damn; for once there is nothing I can do about it.' He
has not much time for notions of posterity either, others or his own, but he
admits that in the end his reputation must rest on his paintings. He has also
experienced painter's block – and he has always come out of it, often by
working with other media, such as xeroxes and faxes: 'I get turned on by a
new media, and I feel much freer in drawing or etching than in painting.'

After the slick paintings of the highly productive Californian years came a long pause. More naturalistic paintings followed, a phase he was not totally happy with. His dealers often urge him to concentrate on painting, but he shrugs them off. 'They all think when I am not painting I am idle. The different things I do are not diversions. By exchanging one artistic convention for another I find things out. They are in a rush. I am not, I have never been.' A Hockney painting can now fetch anything from £250,000 to one million pounds. Not that this interests him very much; as he did in the past when his work fetched £300, he thinks, 'it's all a bit absurd.' So he goes on experimenting, for as he says, 'An artist should be concerned about the way the world goes.' Hockney continues to believe that art is able to ennoble humankind and that it can change the world, not only in its ability to capture beauty, but also in the way it can free our minds and imagination – 'It can make people more compassionate and more profound.' His belief in the perfectibility of humankind has hardly been shaken, despite the evidence of destruction which surrounds us.

In his work, Hockney has a horror of repeating himself. 'Certain things I could do easily, but then you don't want to do them. I could paint ten pictures of swimming pools and make them look rather nice, but that would bore me, which I do not want to do. I don't mind boring you, but I don't want to bore myself.'[42] Moveability and versatility have always been hallmarks of his character and of his work. 'My sources are classic, or even epic themes, landscapes of foreign lands, beautiful people, love, propaganda, and major incidents (of my own life).'[43] To this end he freely and unashamedly borrows styles and artistic devices and puts them at the service of his work and emotional life. With his chameleon-like quality and his resolute transitions, he is re-inventing himself, branching out in new directions, with often disorienting results for his admirers and critics. The different styles sometimes take time to be properly evaluated. I remember many people disliking at first the poster-like paintings of his early Los Angeles days. The same people later considered them among his strongest works. But as he also tells us, 'There is far more unity in

my work than people give me credit for, but people are often too lazy to find
that out and think it through; everything I do grows out of the other.'

In terms of his public persona, none of the attention he receives goes to his
head. All the big public events simply become sources of anecdotes wittily
told to his friends, not to show off, but to amuse.

When he was invited years ago to the White House to dine with Prince
Charles and Princess Diana, he was held up for half an hour in security
because he was the only guest to arrive on foot. He was placed at the
president's table and Reagan, so it was reported, was so confused that 'he
introduced "Prince Charles and Princess David"'. When he was given a
doctorate what most delighted him was that he met another person from
Yorkshire and who was given the same honour – Betty Boothroyd, the
colourful and indomitable woman who had started in the Music Hall and has
ended up as the Speaker of the House of Commons. 'God, I'd like to have a
fag,' was the lady's opening line. Shortly after the two new honorary doctors
were seen smoking outside like two naughty schoolkids. When I asked him
where he was on the day the Berlin Wall came down he replied: 'I'll never
forget that day, I had tea with Elizabeth Taylor. I was captivated by her eyes.
She had come to get a picture for an Aids charity. She came for an hour and
stayed for three, letting the driver wait. It was lovely.'

All this time he has continued to paint or to make lithographs, the influence of
Picasso ever more apparent. His friends were once more his favourite subjects
and the paintings often reflected the different events that had shaped their lives.
There were portraits of Mo and his new wife Lisa, Ann Upton and her new
husband, David Graves, Patrick Procktor was painted with his son Nicholas.
There were also images of the next generation of his friend's children, among
them Paul Kasmin and Jasper Conran. And the faces of Celia, Gregory,
Christopher and Don, slightly more mature, continued to be portrayed.

The Hollywood Sea Picture Supply Co.

In the late eighties Hockney's artistic investigations became more complex. His interest in photography led to his work being readily reproduced in other media. He had bought a fax machine – he called it the 'telephone for the deaf' – and began faxing 'paintings' to his friends. David was besotted with the new medium.

In 1988 Hockney also did about one hundred very small 10½ by 10½ oil paintings of his friends, just the right size to fit on a fax or laser printer. They were executed very quickly and the results were rather rough. The stamp-like portraits filled an entire wall of his studio, a personal portrait gallery of his friends, most of them just the face, staring out at us. Hockney had bought a colour laser copier and was thrilled that the reproductions were even more colourful than the oils. So he reproduced and faxed them around the world from 'The Hollywood Sea Picture Supply Co. Est 1988', to the delight of some and the horror of many. The new gallery in Saltaire, near Bradford, which his friend Jonathan Silver had opened and which was almost entirely devoted to Hockney's work, received no less than 144 sheets of fax paper of a composite picture. The arrival of the faxes was treated as a public event. The museum in São Paolo in Brazil was shocked when the contents of their Hockney contribution to the Bienale arrived via telephone from Los Angeles. The Japanese were rather delighted just to receive laser copies of his work, and by the time the Centro Cultural Arte Contemporàneo in Mexico City received their exhibition by fax, Hockney's provocative stand and comment on the nature of art had become a media event. Many interpreted this as yet another shrewd, media-courting plot of the *enfant terrible* but it was also a philosophical decision by someone who wanted to

break out of the notion that an artist should only do 'original and rare' work. 'COMMERCIAL PRINTING IS AN ARTIST'S (direct) MEDIUM,' he had written in large letters in the catalogue of a show in Los Angeles. He liked the subversiveness of the fax machine. For days David and his assistants fed the fax exhibits into the machine to the sound of Wagner's *Walkyrie*.

It was also the old Dada spirit in him; when the museum director, at the end of the São Paolo show, asked what he should do with the exhibits, David's answer was: 'Just fax them back!' The fact that they were unsaleable delighted him although such is the acquisitiveness of the modern world that soon they were also collected and became a commercial commodity.

The Hollywood Sea Picture Supply Co. was a beach house which Hockney had bought in 1986 in Malibu, an artists' colony twenty miles from West Hollywood. The house is an old-fashioned, wooden weather-boarded one, wedged between a weed-choked front path and the Pacific Ocean. Its simplicity and unpretentiousness is refreshing in contrast to the grand villas and manicured lawns. There are three small bedrooms and a large living-room that gives out onto a wooden deck with an open fireplace which David is especially proud of. A couple of wicker chairs, a table and a sofa complete the decor. On the walls hang some of the small portraits of his friends – Brian Baggot, Helmut Newton, Henry Geldzahler, Armisted Maupin and Maurice Payne. Some are the original oils, others are just laser copies, and David is delighted when people can't tell the difference. He even allowed a German gallery to show the paintings side by side with the colour reproductions.

Behind the house a steep staircase with an old-fashioned stairlift leads to a small studio, 'the smallest I have had for a long time. It became a place of great artistic exploration.' One painting done here was named *Where Now?*.

In the beginning David came here to escape the social life of his house on Montcalm Avenue and the constant solicitations for dinner parties or

interviews. He sometimes stayed for several weeks and the quietness of this time is reflected in his works. Once more Hockney scrutinized his environment rather than the people around him. He did many unpeopled interiors of his homes and a series of chairs based on van Gogh. The paintings in dazzling *Fauvist* colours were almost like designs for stage sets, waiting for the actors to make their entrances. He used to sit in the living-room and look out on the ocean, as it threw up spray a few feet away. 'I love the sea and its seemingly endless space and I love the way the space finishes on the horizon.' The perception of space has always been one of his main concerns. 'Space demands from us an emotional response.' Hockney likes great vistas: the Grand Canyon, the panorama from the Hollywood hills of the vast and sprawling expanse of Los Angeles below, and now the uninterrupted view of the sea. Listening to him, I contemplate that even this man, who seems to have everything, is still yearning for something bigger, richer.

To many of us he has been a constant yet not always comfortable friend. The discomfort comes from his unpredictability and his understandable desire not to commit himself too firmly to one thing or to one person – an absolute necessity for someone who needs space for his work.

He rarely says anything critical about other artists: 'I always feel it needs all sorts. I might be indifferent to their art, but I would never put another artist down.' But he is no longer silent when he decides that things are bad. He can also get bored easily and suddenly, in the middle of a conversation, he can rise and disappear into his studio, not to be seen for hours. David has always been impatient, and he deeply resents it when things go wrong. He hates to be pushed around and told what to do. 'I get worried when I have too many commitments, too much pressure, too many deadlines, so I go to my studio and paint. When you are painting you seem to have all the time in the world.'

Sometimes in the past when I have been alone with David he has allowed a

glimpse into the landscape of his heart. Now, on this my latest visit he is even mellower than before. His life has been marked by exciting adventures through his travel and new encounters and has included many arrivals, partings and leave-takings. I asked him why all the boys he had loved share similar qualities, not just physical but also mental ones. 'Yes, they were essentially gentle, not aggressive, they were also visual. I do not like shallow people... but somehow even two people sharing drift apart.' I asked him what he would do if he could redo his life? 'I don't think I made great mistakes, quite a few small ones. I might be a better artist if I were more disagreeable.' And what does he consider his worst quality? 'I wish to be in control all the time about my work, my friends, my time,' and after a long pause, he adds with disarming honesty, 'People think I am easy, but I am tough, it gives me the space I need for my work.' His relationships have always been located between exhilaration and sadness. David is aware that he still as to learn that the need for that great freedom he claims for himself has also to be linked with the freedom he is willing to give to others, especially those he loves – a balance between independence and commitment.

And his best quality? Hockney does not hesitate: 'My loyalty to my friends! . . Love for me is really the most important thing.' Loving for him means loving the world – 'It helps you to conquer your fears' – he once told me. To fall foul of that maxim is almost unforgivable, the ultimate betrayal. But he is honest enough to admit the difficulty he has in sustaining loving relationships. In his undying enthusiasm for his work and in the public demand upon his time there is little space for anybody else. 'I sometimes do not leave enough life for my lovers, and when they claim it, like Peter did and Gregory did, life gets difficult, and things fall apart, emotionally at least.'

David likes the conquest, but lingering is not for him. The act of love-making has been central as a life-confirming force for so long, and when it begins to slip away, it's sometimes not easy to cope – that absence of a warm body he can reach over to in bed – 'It's not sex, but tenderness.' Hockney the artist

needs to feel an emotional response or else he cannot paint a person, 'I have to care for a person to paint him.' When Peter left him, the human figure disappeared from his work until new lovers filled his life. We look together at some erotic drawings he did when he shared the house with Ian Falconer. All the things David hardly ever talks about are there in his work. When Keith Vaughan's sexual urge stopped because of his cancer, he stopped painting. David is much moved when I tell him that painting is like love-making.

Fifteen years ago, when his house and life was filled with hordes of lively young men diving in and out of the pool and the public acclaim seemed undiminished, he told me; 'As disillusion sets in it will occur in your work, and I suppose over the years I have withdrawn a bit more because you think it is all a bit mad or too fussy.' The many video stills he did in 1990 and 1991 of *L.A. Visitors* still show an endless stream of visitors, although already in those years there was an inkling of lonelier times to come.

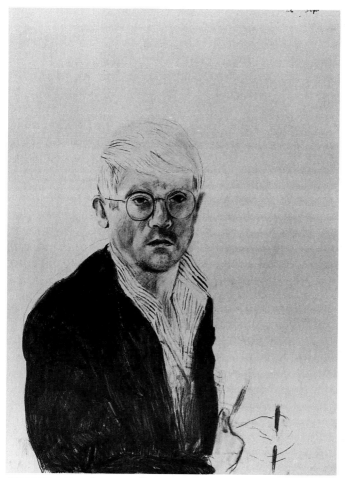

SELF–PORTRAIT 26 SEPT. 1983, CHARCOAL

'We have a deep desire to survive because
we like the experience of loving.'

The shadow on the wall

In recent years death has become a constant companion. His father's death in 1978 was a marked and sad event. 'Dad was the first person I lost who I felt really close to. It was like a piece of myself leaving me.' The sorrow he could not express in public can be read poignantly in a drawing he did of his mother on the day before the funeral, a tender image of grief.

But his father's had been a rich and fulfilled life. Much harder to accept has been the death of many friends from AIDS. At some moments, David flew weekly to New York 'where four friends were dying in four different hospitals'. He also few to Paris to visit his friend Jean Léger who was mortally ill. Like so many, he experienced the bleak despair that chokes one when entering a ward. Everywhere the ravishing became the ravished, rooms of emaciated bodies of the young with faces of the old. Like so many, he tried to help, to council, to share grief, sometimes lugging a painting of a huge sunflower with him, saying: 'Get well soon!'

David can not forget the long rows of funerals and memorial services he attended: 'It was a terrible emotional turmoil, it literally tore me apart.' Hockney's great capacity for human compassion which has never left him was evident in his many gestures and in his generous contributions to AIDS charities.

The mad dance of death effected him deeply. The world of his friends began to crumble, first slowly, then with accelerating speed. When Ron Kitaj's wife, Sandra Fisher, died, he took the next plane to London to be with his old friend. When Ann Upton's son, Byron, was killed, David rushed to London

to help heal 'the terrible wound'. He flew to London again to be with Celia and her children when Ossie Clark was murdered.

In 1996 he is sitting opposite me, reciting the long list of the departed, people he had known, shared a bed with or a drink. The emotion is still visible on his pale face as he lists the tragedies which had reached almost everybody he knew: 'Nick died six years ago, Jean Léger, Nathan Kolodner, who looked after me at Emmerich, Joe MacDonald, Jacques, Mark and John.' So many people, the most shining, the most brilliant, the most hopeful – friends aged thirty, thirty-five or forty years old. The American hero of so many of his paintings, the sexy image of life and physical pleasure, the icon of healthy living, the American Dream, was no more. His friends stand in the room like ghosts. 'The painter Mario Dubski, Andy Warhol, John Dexter, Robert Fraser, Mario Amaya, Sheridan Dufferin, Rudolf Nureyev, Robert Mapplethorpe. We have lost Christopher Isherwood, Henry Geldzahler.' Peter Langan burned to death at his home: 'I only found out when I saw it on the headlines in the *Evening Standard*.' We both realize that the world of art has lost some of its most brilliant practitioners. Mo McDermott died of liver failure due to alcohol: it is the only death David cannot forgive. With the life of so many friends ending so early, due to no faults of theirs, Mo's dulled and finally squandered life by alcohol was like a betrayal.

Many people are amazed that so little of the pain and sorrow he has experienced has found its way into his art. But the pain is there. When Howard Hodgkin visited him in 1979 he painted three paintings. In one, *D.H. in Hollywood*, the melancholic isolation which has set in is clearly visible for those who know him well.

The pleasure-loving, free-wheeling homosexual community has discovered a new stoicism, compassion, responsibility, but also rage. A world that had been shamed into silencing its prejudices for a time saw in AIDS an opportunity to re-evoke 'AIDS as a punishment for a wicked life'. The idea of sex as a

source of pleasure was again tested. Anger still wells up when David talks about the convenient blaming of the moral majority. He's raged against the British government which set itself up as the apostle of a spurious morality and threatened to cancel a big exhibition of his work at the Tate Gallery in protest at the anti-gay legislation which the Thatcher government had proposed. Parliament had provisionally passed a ban on promoting homosexuality in schools, in the theatre, on television or in museums and libraries. The infamous Clause 28, later to become law, brought many liberal-minded people onto the street.

A natural dissident, he is a consistent and brave campaigner against injustice and the increasing heartlessness and insensitivity of the world pains him. David has, to use an old-fashioned word, 'standards'. He will fight whenever he can what he calls the 'Committee People' the self-appointed moral majority. His capacity for engagement is still total – and can take odd forms. At present, he has been rallying against the American laws forbidding people to smoke in public places. At a conference in the Los Angeles County Museum he told an audience who had come to be lectured about his art: 'The peasants have taken over, this is another way to control our lives. I am sick of it; instead of teaching the children something, they indoctrinate them with their puritanical Coney Island mentality.' There was polite applause at his angry outburst. At home the anger does not subside: 'Politicians never tell the truth, they do not know the meaning of the word. I want to decide about my own pleasure, I will die that way,' he tells me.

David himself has hardly ever been ill. The only suffering he has known has been through loneliness or the loss of lovers. There have been betrayals; people have pinched drawings or rummaged through his wastepaper baskets to find any scrap of paper which could be sold at auctions. But the real sense of betrayal is with the slow erosion of a relationship. His latest lover, John, had only just walked out on him and David tries hard to hide the hurt. I ask him if he has ever thought of killing himself and he responds, 'We all have

sometimes, but it lasts a short time. When you go to the Grand Canyon, you can drive to the edge and just go on driving, but I know the minute I would go over the ridge I would regret it.' His affirmation of life is strong: 'We have a deep desire to survive because we like the experience of loving.' He sees it as his duty as an artist to dispel the feeling of despair that is in the world. What sustains him is his work and his love of life. He has never lost the capacity to enjoy life on a very simple level. His wit and curiosity about many things are great allies against the rising waters of despair.

His greatest suffering is the increasing loss of his hearing. He knows much about deafness as his father had been deaf for many of his later years. David noticed his own faltering hearing for the first time fifteen years ago during a lecture. In the beginning, he wore two hearing aids, one in each ear. He didn't mind people seeing them, he even made a feature of them. He told me that if they had come in different colours, he would have worn them, like his different coloured socks or the old lamé jacket, all expressions of his personality.

Hearing, like seeing, is a spatial experience. 'My deafness has made me see space much more clearly. I accept more readily visual space. It's the opposite of the blind, who locate themselves in space though hearing.' Too much has been made of David as a sad and disillusioned artist. The old optimist in him is hard to kill. 'People are always saying "times are bad". Well, it's the best we have, it's ours for a start. Maybe if we start talking more about beauty, which is all around us, well, at least for those who have eyes. Of course art does not reflect much of it nowadays.'

Now, with loss of much of his hearing, his life has become quieter, although the colourful and changing world of hangers-on, admirers, dealers and collectors has hardly diminished. There are still a number of handsome young men around his house, but the cheerful camaraderie of the gay crowd that livened up an evening has lost much of its shine. David often remarks that

during the last few years his life has become 'lonely'; the sense of isolation through his deafness upsets him. He talks openly about the absence of sounds: It's not the same as silence, silence I like.' He no longer goes to concerts, but listens to music in bed with the help of earphones or in his car. On his journey to his beach house through the Hills behind Malibu, he has devised what he calls 'his Wagner Drive'. A cassette in his car plays Wagner's music in accordance with the landscape he drives through, 'a musical spacial experience.' He used to love going to parties or openings and to just chat to anybody around, but the old urge to go out and to meet people has gone. He avoids large crowds and even smaller dinner parties or visits to restaurants are difficult. 'I go out less, but I have my two houses. Here I can work, smoke, sit next to whoever I want, look at this garden, how beautiful!' Those who know him well can see that his world has grown a shade more sombre. As always, he is reticent to talk about it; he does not believe in sharing his suffering with others. The new mood is perhaps best seen in the models of his life drawings in recent years: they are no longer always handsome young men, but his dogs Boodge and Stanley whom David dotes on. Tender and humorous portraits of the dachshunds are dotted all over the house and line the studio walls. The dogs have become a signal of the more domestic life David now leads.

In dress too he has become more subdued. The baseball cap has been replaced by a smart Panama hat. He might still wear two different coloured socks to an opening of a Lichtenstein exhibition, but for a Wagner evening at Covent Garden he sports a smart suit.

He reads more than ever. There is always a large pile of books on the floor next to his bed – the new biography of Thomas Mann, a book on science or David Freedberg's *The Power of Success* – and, as in the old days, he talks to his visitors with great passion about whatever he is reading. The desire to share has not ebbed away.

There is still plenty of public recognition and acclaim. For a recent lecture he gave in the Los Angeles County Museum I stood among a crowd of mostly young people and women, gaily chatting in anticipation of a major cultural event. David passed and waved at me from afar. Two women turned towards me: 'You know David Hockney?' slightly embarrassed, I nodded. 'May we touch you?' When I told David this story he was not put out. He has become a great star, the demi-god of a world that craves for fame. And he loves it.

The house on Montcalm Avenue has also seen quite a few changes, reflecting Hockney's success, organization and desire for privacy. A guest house has been added and through a corridor you reach his inner sanctum, a small library-cum-living-room with a giant television set where David spends most of his evenings. In the main room there is a vast area for eating and cooking with a couple of big armchairs around a fireplace with a *trompe-l'oeil effect*. A piano completes the furnishing. A new studio, built on the old site of the tennis court, provides generous space, the floor covered in splashes of paint. There is hardly any furniture, except for a couple of wooden easels and two chrome typing chairs for David to sit on to scrutinize his work. The walls are peppered with his paintings, mostly portraits of his dogs. Not many people are allowed to enter here; it is Hockney's realm and that of his alter ego, friend and assistant, Richard Smith, an unflappable young man of calm and balance. He, Gregory Evans and David work closely together on many projects. In the past, David often involved himself in the hanging of his pictures at exhibitions. Now Richard and Gregory build scale models of the rooms and in them they hang miniature versions of the paintings, so that nothing is left to chance. David, not unlike the painters of the Renaissance, has always liked to work with his friends and lovers as assistants, and he is generous in publicly recognizing their contribution.

The telephone never stops ringing and sometimes he phones his friends, adjusting his very complicated hearing aid. When his call is picked up by an answering machine, he changes his voice: 'You are hearing the voice of David

Hockney calling, calling, calling . . .' With his broad smile he turns around, 'It's always machines talking to machines here. You have to talk like a robot.'
The overweight dachshunds, with their baleful eyes, stand on their hind legs like a circus act and look lovingly at their master. 'Look at Boodgie and little Stanley, they are complete. We have so often done things we did not really want to do, lived such detours. The dogs are in harmony with the world, with this place. When it is cold they sit next to the fire, when it is hot they look for shade. It's all so much simpler. That's the way I want my life to be.'
For a moment he really believes it, and then he gets up and walks to the table, piled with books and magazines on the subject of Hockney; a new book of Hockney posters put together by his old friend, Brian Baggot; a Christies' sales catalogue of the collection of Henry Geldzahler; a publication with Hockney's recent paintings. He proudly fishes out from underneath the pile the invitation cards for his up-coming shows in New York, cards designed and produced here in Los Angeles under his supervision.

The old studio on Santa Monica Boulevard is now used to run the 'Hockney industry': prints, books, posters. He even has a personal secretary, Judy, trying to keep abreast of the numerous letters that arrive daily. In the past they used to disappear into a drawer, sometimes unopened. We talk about his capacity to change lovers into 'best friends'. 'That's my family,' David says. 'They all come back, Peter is still a good friend and a painter and Gregory is back after twenty-six years and designs fabrics, Ian Falconer too, is still around, doing cartoons for the *New Yorker*, John just left me, but I am sure he will be back,' David says proudly, 'Maybe it has not all been in vain. There is at least some consistency in friendship, even if "love" is such a precarious thing.'

David has always had a talent for surrounding himself with people that get life going for him. A vivacious woman from Guatemala, Elsa Duarte, looks after his physical well-being and, of course, figures in his paintings. And his capacity for enjoyment continues to take many forms. He still fancies quite elaborate meals, which his last friend, John Fitzherbert, who came from

London to live with him, was an expert at producing. But the source of enjoyment can still be simple: he points at a new dishwasher. 'Only rich people are not impressed by these new inventions, because they have never washed up themselves.' He gave his mother, Laura, a new microwave for what she calls 'cooking in a television set'.

Laura is ninety-five years old. He still paints her every year, his most enduring love affair. She no longer travels to Los Angeles as in the past, for their games of Scrabble and 'she complained that people had no washing on the line outside their houses', but David still phones her daily and often flies home to visit her in Bridlington, where she now lives with his sister. He likes Bridlington because he can walk about without being bothered. People wear "Kiss-me-Quick hats".' When he is with his family he is just like them. However much America has adopted him and he adopted its lifestyle, Hockney's spiritual pedigree is European, but he has followed Churchill's dictum: 'It's an Englishman's inalienable right to live wherever he chooses'. The whole business of nationality has always been quite strange to him. He simply has too many friends who are not English. 'Los Angeles is now really my home,' he announced one evening. Despite all that, there is still something intensely English about him. Unlike many emigrants, the other half of his life has not been sliced off, the half that began in Bradford is still there and nourishes the new life, balancing it and pulling it into focus. It is this that saves him as a man and an artist. Friends have always wondered how he reconciles his desire to escape his Bradford past and to still want to be a part of it. The answer lies in the fact that he has very strong roots. He is like a tree, the branches going off in different directions, but still nourished from underneath. He is still the modest Bradford boy leading you through the overgrown garden with the enthusiasm of a child showing off his toys.

When asked if success has been a burden or a pleasure or both, he thinks for a moment, and then, with an almost sad face, he replies: 'Both, but I never think of myself as that successful an artist anyway. The duty of an artist is to

know your own limitations. One always struggles to do something better, pushing against the edge. I get depressed when I don't work, and when I am depressed I cannot work. It's a vicious circle, but you fight that. I must express the feeling – that of love. I think one wants the art to communicate, to share an experience and make it so that it can be relived, vividly.'[44] Art for him has something to do with 'sharing', with removing the distance that separates us from each other.

Hockney hates anything lukewarm or, in painting terms, what he calls 'middle of the road' or 'mainstream'. 'The periphery is more interesting'[45] and this honest verdict applies to his work and his life. Marginality has suited him, and given him a freedom 'mainstream' would not have offered. He does not care if his work fits, as he cares little if he himself fits so long as people care. 'I do not mind standing a bit alone, as a man and an artist . . . I have always been out of step with the world in a way, I never quite understood its desire for destructiveness.'

Critics of his work have wondered about his lasting success and the adulation of a mostly young audience. It is too easy to find the explanation for his popularity in the fact that he is a figurative painter. Nor can his engaging media personality explain the phenomenon. But many people, who normally would not go to an exhibition, will go to a Hockney. His sensibility and perceptions are not obscure; there are no moral points, no mythological detours or intellectual acrobatics to navigate; he speaks directly to the viewer. The stories he tells are instantly readable. I believe his seductive quality is based on the magical way his work gives many people the feeling of participating in an adventure. He is a man of the theatre, and he provides intrigue, challenge, entertainment. Many people feel that he is just like them, a man who expresses himself from the vantage point of his own solitude, without moralizing or judging. He has been the most generous of artists, constantly opening our eyes to the world. In a milieu where notions like 'popularity' and 'communication' no longer seem to concern artists, he has

shown that enjoyment in art is still possible. What he is really after is to give pleasure and his faith in beauty is almost absolute. And so it is only natural that he enjoys the fact that people like his work, and his childlike obsession with himself and his art is undiminished and disarming. He might at times be critical of David the person, but there is no false modesty when it comes to his work. He knows the worth of Hockney the artist, but he is too intelligent not to know his limitations and too wise to show off. He carries the label 'popular' with pride. 'Critics talk as if being popular is a crime. Anyway, what does the word 'popular' mean? Probably Beethoven and Mozart are the most popular musicians, in a hundred years they'll still be listened to. There is, of course, a kind of temporary popularity, people come and people go, but in the end if you use the word in its proper sense, what is really popular are wonderful things.' These were his closing words in my film *Hockney at Work*. David was sitting on the floor, sloshing large amounts of paint onto a canvas. Fifteen years later this belief still holds. He has often said that 'one can only make pictures for oneself' but he hopes that his art has a universality of feeling, 'like any good art'. This is not an arrogant statement of someone overestimating himself, but a plea to us not to sell-out beauty.

In 1995 Hockney had begun once more to take his experience with the theatre and use it in his paintings, but this time in a much more radical and direct way than in the past. In Munich's Haus der Kunst, he decorated an entire room on the subject of the harlequin, painting directly on walls and floor. The 'visitor' could either walk through his 'installations' or sit in front of them. His delight in artifice is also seen in his latest work, a play with light, combining his love for painting with the art of the theatre. The very large paintings, some covering whole walls and spilling over onto the floor, were devised with the aim of being able to change the light, like a theatre set. These complex installations have involved a lot of experimenting, and once more David has relied on the collaboration of Gregory Evans and David Schmidt.

His last New York show stretched over two galleries. David flew in and took

a look at the walls. 'White walls are so fucking antiseptic,' he declared and he had them painted in different colours – black, blue and red. Then he placed his gigantic painting which changed colours in a light show which lasted nine minutes. People sat on chairs as in a theatre and watched the blazing colours transforming under their very eyes. At the 'opening night', which as always drew a fashionable crowd, I spotted Celia Z, Gregory Evans, Peter Schlesinger, Brian Baggot, Maurice Payne, David Schmidt, John Fitzherbert, Ian Falconer, Arthur Lambert, Ann Upton, David Graves, Paul Bartel and Stanley Donan. It was an evening of and for David Hockney and his friends.

I flew back to London with a mixed felling of sadness and elation. It is good to return to places where one has been happy in the past, but to return to a place we love is always flawed, because what we loved was not only a place but a time. On our last evening, David and I had talked about Simone de Beauvoir's remorseless look at her life and the forlorn sense of lost time in *La Force des Choses*. So many moments gone beyond recall, so much on the descending side of life. But then I thought of David's last remark: 'I've got my eyes and I use them, I can enjoy a shadow on the wall.'

STANLEY, 1993

Notes

1. Bryan Robertson in *The New Generation*, 1964.

2. *Hockney on Hockney,* Thames and Hudson, London, 1976.

That's The Way I See It, Thames and Hudson, London.

Further monographs deal with specific aspects of his work:

Paper Pool (1980)

China (1982)

Hockney Paints the Stage

3. Quoted by Bryan Robertson, op. cit.

4. From *That's The Way I See It,* p. 137.

5. Robert Hewison, *Too Much: Art and Society in the Sixties,* Methuen, London, 1983.

6. From BBC documentary *David Hockney At Work.*

7. Interview with Mark Livingstone, *David Hockney,* Thames and Hudson, London, 1981.

8. Peter Webb, *Portrait of David Hockney,* Chatto & Windus, London, 1988. p. 30.

9. Mutual fellatio is also the subject of another painting of the same period called *Teeth Cleaning W 11.*

10. From *In Paths Untrodden*

11. From *For You Democracy*

12. Whitman, *Calamus*

13. Auden, *Dichtung und Wahrheit (an Unwritten Poem)*

14. Hockney, *That's the Way I See It,* op. cit.

15. In *David Hockney by David Hockney,* p. 99.

16. From Peter Adam, *David Hockney At Work,* op. cit.

17. In *Private View,* Thomas Nelson and Son, London, 1965.

18. From Peter Adam, *David Hockney At Work,* op. cit.

19. ibid.

20. *Hockney on Hockney,* op. cit., p. 101.

21. Translation of Cavafy by Cyril Winters

22. Peter Webb, *Portrait of David Hockney,* op. cit.

23. Mark Livingstone, *David Hockney,* op. cit.

24. Keith Vaughan, *Journals 1937–1977,* John Murray Ltd, London, 1989. See also Peter Adam, *Not Drowning But Waving,* Andre Deutsch, London, 1995.

25. Peter Adam, *David Hockney At Work,* op. cit.

26. ibid.

27. ibid.

28. ibid.

29. Peter Adam, *Not Drowning But Waving,* op. cit., p. 289.

30. ibid., p. 234 ff.

31. *David Hockney by David Hockney,* op. cit., p. 204.

32. From *Hockney on Hockney,* op. cit., p. 204.

33. ibid., p. 287.

34. Peter Adam, *Not Drowning But Waving,* op. cit., p. 222 ff.

35. Mark Thompson, David Hockney in *The Advocate,* January 28, 1976.

36. Peter Adam, *David Hockney At Work,* op. cit.

37. Peter Adam/David Hockney, *One Hundred Great Paintings,* BBC Television.

38. Peter Adam, *David Hockney At Work,* op. cit.

39. ibid.

40. ibid.

41. *The China Diary* published by Thames and Hudson

42. Peter Adam, *David Hockney At Work,* op. cit.

43. Image in Progress, 1962.

44. Peter Adam, *David Hockney At Work,* op. cit.

45. *Hockney on Hockney,* op. cit., p. 128.